Dark Art

IMPACT

Dark Art

Draw and Paint Witches and their Worlds

Bob Hobbs

A DAVID & CHARLES BOOK
Copyright © David & Charles Limited 2009

David & Charles is an F+W Media, Inc. company
4700 East Galbraith Road
Cincinnati, OH 45236

First published in the UK in 2009

Text © Bob Hobbs 2009
Illustrations © Bob Hobbs, except where indicated otherwise

Bobb Hobbs has asserted his right to be identified as author of this work in
accordance with the Copyright, Designs and Patents Act, 1988.

A catalogue record for this book is available from
the British Library.

ISBN-13: 978-1600-611-537
ISBN-10: 1-6006-1153-2

Printed in China by Shenzhen Donnelley Printing Co Ltd
for David & Charles
Brunel House, Newton Abbot, Devon

Senior Commissioning Editor: Freya Dangerfield
Editorial Manager: Emily Pitcher
Editor: Verity Muir
Art Editor: Martin Smith
Project Editor: Nicola Hodgson
Production: Kelly Smith

Visit our website at www.davidandcharles.co.uk

David & Charles books are available from all good bookshops; alternatively you can
contact our Orderline on 0870 9908222 or write to us at FREEPOST EX2 110, D&C
Direct, Newton Abbot, TQ12 4ZZ (no stamp required UK only),
US customers call 800-289-0963 and Canadian customers call 800-840-5220.

This book is dedicated to all those who perished in the flames of ignorance and fear during The Burning Times and to all those who still suffer persecution or death for being a Witch.

Contents

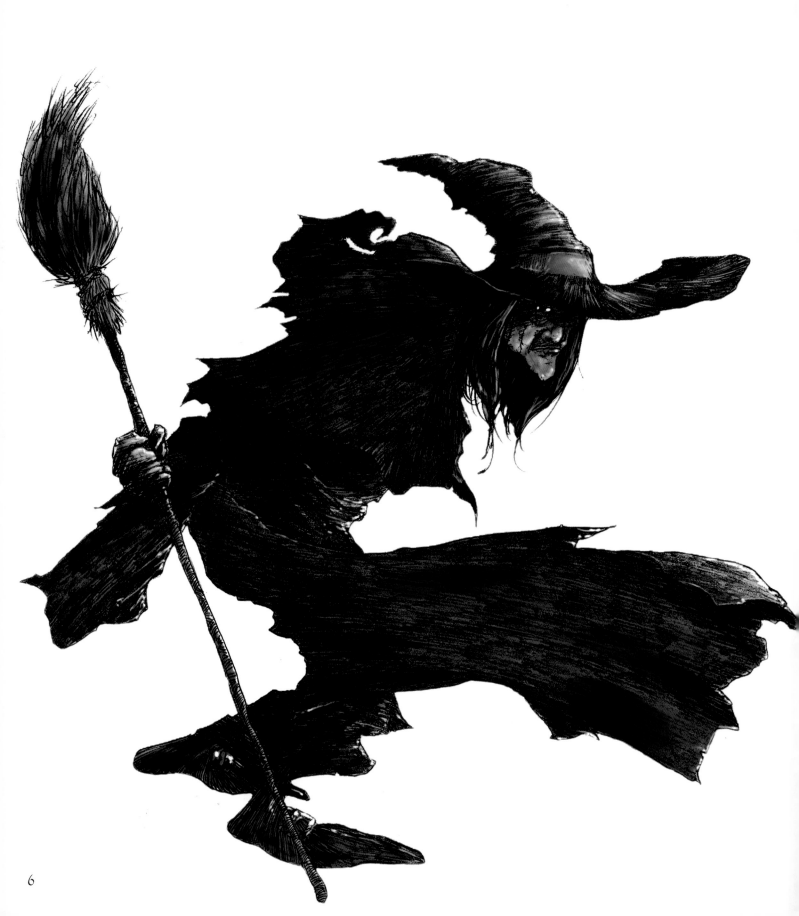

Introduction

The mysterious and enchanted world of witches has long held the fascination of mankind. What began as a form of worship to the gods of fertility, the harvest, birth, death, the Sun, the Moon and nature evolved into what was considered by the Christian church as an evil cult challenging the authority of what they considered to be the one true God.

Witchcraft went underground and survived through the centuries, re-emerging here and there, gathering new converts and passing along ancient wisdoms, customs and practices.

It finally saw a new awakening when an Englishman by the name of Gerald Gardner declared himself openly as a witch in 1954, and began publishing books on the subject. England repealed its witchcraft laws just as the world was entering an age of exploration into new ideas which included art, music and literature. New freedoms allowed people to embrace witchcraft without fear of punishment. Wicca was born and is now the most popular and well known of the Pagan faiths.

Since its revival, there has been a firestorm of controversy and protest blaming the rise of evil in the world on the popularity of Wicca and witchcraft. In some areas of the world witches are still persecuted, harassed and even killed. However, for the most part, witchcraft has become a cottage industry and a favourite subject amongst many individuals today.

As such, there's an increasing need for artists who specialize in the subject of witchcraft, magic, sorcery and enchantment... what used to be called 'make believe' is now called fantasy. There are a host of artists who have built a career on drawing and painting dragons, wizards, faeries, gnomes and all manner of creatures who inhabit the world of magic.

This book focuses on witches – long a staple of fairy tales, legends and folklore. But there are two types of witches that must be distinguished early on. There is the fantasy witch that you find in traditional stories such as *The Wizard of Oz*, *Sleeping Beauty*, *Hansel and Gretel* and the like. They have the stereotypical pointy black hats, black capes, brooms, hooked and warty noses, green skin and an evil disposition. This is the type of witch that populates most of what we know as fairy tales and folklore.

More recently, television shows such as *Buffy the Vampire Slayer* and movies such as *Harry Potter* and *The Lord of the Rings* (as well as a plethora of computer games and graphic novels) have brought witchcraft and sorcery into people's homes and living rooms around the world.

Today, people are well aware of a second type of witch who dresses much like everyone else. The modern witch has a day job, a mortgage to pay, children to put through school and is planning for retirement. Wicca is now a recognized religion. Modern witches can be male or female, have any manner of job and vary in looks. These are the real witches who don their hooded robes for Sabbats and meet in covens located in everyday suburbia.

This book will lean more heavily on the stereotypical witch since we're dealing with legends, folklore and fantasy. But I will inject a bit of reality with the inclusion of facts about witchcraft, the various tools of the trade, ancient symbology and the like, so that your artwork will have a foundation.

I have been what we call a Seeker for over ten years now. I practise magic and cast spells, but my main focus is on research, gathering information, seeking connections and exploring the dark corners in search of hidden truths. I've been an artist for over 30 years, most of that time spent as an illustrator. I now combine the two disciplines to create what is commonly known today as Dark Art; artwork that embraces the darker subjects of horror and the occult.

I also call myself a warlock as opposed to the currently accepted practice of calling males and females witches. My reason for that is complex, is based on newly uncovered facts and a step not taken lightly as it goes against the grain of nearly all Wiccans alive today. But that is another book.

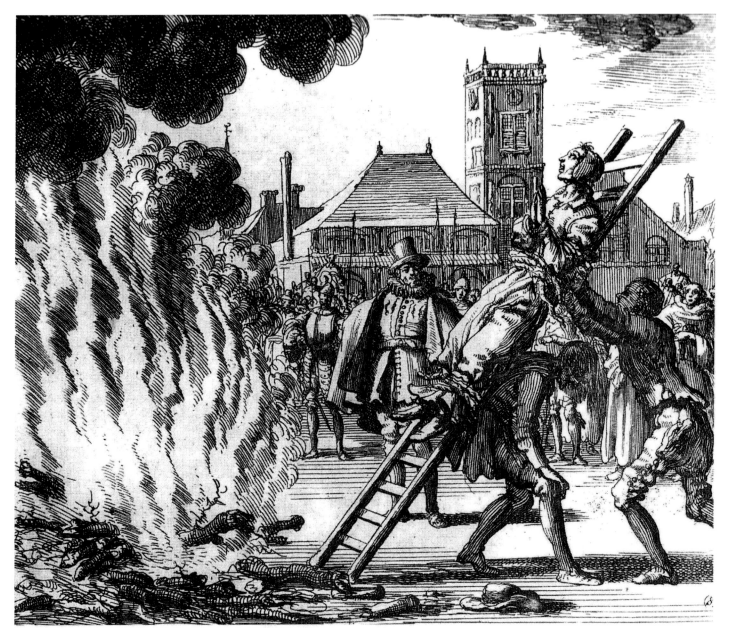

Witch burning in Amsterdam 1571, by Jan Luyhen

A Brief History of Witchcraft

Witchcraft is the use of certain kinds of supernatural or magical powers. A witch is a practitioner of witchcraft. Anyone who deals with the unexplained, the supernatural or magic of any kind is now called a witch. The term 'witch' has developed to encompass many different practises worldwide, including Shamanism, Voodoo, Mysticism and some practises of the priestly castes. The word itself stemmed from the German word 'wicken' - to bewitch, to the old English 'wicca' – male witch – and 'wicce' – female witch.

How witches evolved

After the ancient wars, battles and distribution of lands came pockets of people, tribes settling throughout the world, especially in Europe. They survived off the land, created their own gods and, over centuries, assembled a composite of concepts for their society to live by.

They were simple people who gave great reverence to the power of nature-based beliefs, such as holding the oak tree sacred.

They relied on concocting potions and ointments, casting spells and performing works of magic to address sickness and unknown malady. They also used spells and magic as a social control mechanism. These practises, which were known by only a few, became collectively known as witchcraft.

The Romans and the Pagans

The word Pagan means country dweller. The most powerful force of Europe, the Roman Empire, grouped all who worshipped any other god except the one dictated by them as Pagans in their effort to enforce their theology.

Decreeing that the Pagans worshipped demons and Satan whether they knew it or not, the Romans declared that these country dwellers were a backward people who had no academic form of reasoning. The Romans consequently began to enforce laws to reduce and eradicate Pagan practises.

Pagan music, religion and magic were all deemed to be invented by the devil, whose aim was to keep humanity away from the salvation of the world. Meanwhile, Roman theology weaved much of the Pagan practises into their own religion. The Romans recognized, craved and feared the power of this witchcraft, which maintained and could transform social relationships within any group. Today many of our rites and practises can be traced back to the early Pagans, such as Easter eggs and rabbits, the May pole, celebrating Christmas in December, mistletoe and Halloween.

The witch hunters

In order to secure plenty of game for food, the country dwellers (Pagans) would perform dancing rituals while wearing animal skins and horns. This simple ritual was condemned as evil and gave rise to the ideas of shape-shifting and demons with horns.

The laws against Pagan practises gradually became more severe with the addition of the death penalty, where anyone found guilty was prosecuted not simply for a crime against society but for a crime against God. King James, after whom the New Testament Bible is named, had a particular fear and hatred of witches and was responsible for the often quoted passage, "Thou shalt not suffer a witch to live". This became a rallying cry for the witch persecutions, a cry that was based on a poor and possibly deliberate mis-translation of the original Hebrew text, which does not mention "witches" at all.

To be accused of The Pact, where the said witch deals with the devil out of their own free will, ensures instant death. The use of torture of the cruellest kind often led to forced confessions and accusations of others. The victims would admit to anything. This led to the generation of even more false information about the nature and practises of witches.

Witch hunting was fueled by monetary rewards offered by the Church, and resulted in thousands of deaths throughout Europe.

Often old women, widowers or simply people who were disliked were accused of witchcraft, executed and their property taken. This gave rise to an unbridled wave of people being tried on evidence that was flimsy or pure hearsay. The most famous witch hunter was Matthew Hopkins.

Witches who survived the Burning Times went underground and kept their practices secret.

Goth Craft

With the introduction more readily available information, the younger generation has begun to question much and appear totally dissatisfied with the answers. The Goth culture has allowed them the freedom to express themselves in music, art, ideas and fashion to show their distaste for conformist social rules. It wasn't long before the Goths discovered witchcraft. Because of its lack of strict rules and dogma, its liberal ideas, anti-establishment outlook and the fact that it goes totally against the grain of Fundamentalist Christian views, many Goths have embraced witchcraft wholeheartedly. They have created their own tradition where witchcraft practices are blended with the Goth point of view.

Techno-Pagans

The Internet has also given birth to a new wave of witches. The 1980s saw a merging of witches, high technology and the computer culture. As it turns out, a surprising number of modern witches are highly educated and very computer savvy. Thus Techno-Pagans were born. The Internet has allowed witches to communicate, gather and share information on a global scale. The Witches' Voice (www.witchvox.com) is the largest online community of witches and Pagans in the world, with an average hit count of over a million a day.

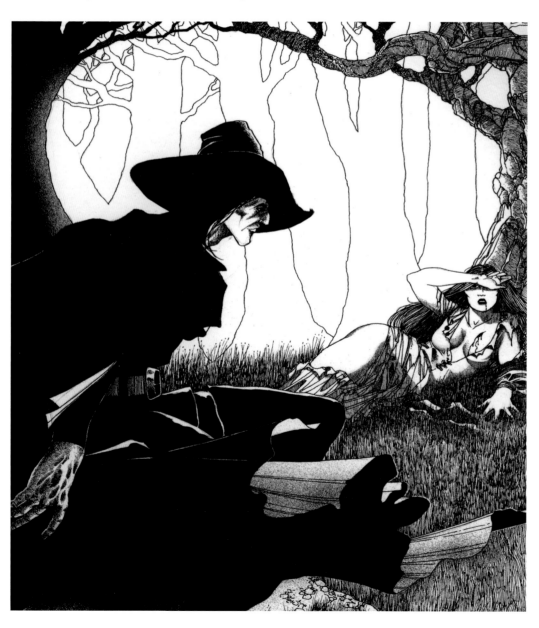

Witch Hunter, by Bob Hobbs

Starry Witch Hut, by Yaga Kielb

The Modern Witch

Witchcraft today is vastly different than what was practised by Pagan cultures of the distant past. Most of the major religions have remained basically intact throughout the centuries through the established churches, the clergy and family traditions. Witchcraft, on the other hand, was overshadowed by the other major religions, which for the most part sought to stamp it out. It was branded as an evil practise and all those who refused to convert to the new religions were eliminated. Witchcraft was forced to go underground.

Memories, by Korvis

Free enterprise has certainly taken notice of the popularity and money-making potential of witchcraft. The Internet is now inundated with websites selling everything from custom-made wands, altars, ceremonial tools, herbs, crystals and love spells. Most large bookstores have an entire section devoted to witchcraft. Llewellyn Publications, based in Minnesota, is one of the largest publishers of witchcraft books. Its founder, Carl Llewellyn Weschcke, is a former Wiccan High Priest.

Magic and occult shops have sprung up in most major cities, where witches can purchase everything they need from tools and clothing to ritual materials and books.

Modern witchcraft is very politically, socially and environmentally active in today's world. Considering most modern witches are highly educated, computer literate, business savvy and well informed, they are in a much better social position than their ancestors and are, therefore, able to influence change.

Covens meet in a variety of places, from quiet suburban homes to big city condominiums, from well known landmarks such as Stonehenge to remote sacred grounds in the middle of forests. The need to meet in secret, while still practised by a few, is largely a thing of the past.

Aside from those witches who dress in Goth fashion or wear elaborate costumes at Renaissance Fairs, most look and dress like everyday people. The majority still wear either a pentacle ring and/or a pentagram pendant as an identifier, a statement of pride or for magical protection.

While a great many witches belong to a coven, most are solitary practitioners, either by choice or because they live in areas too far from an established covenstead. The Internet has been instrumental in keeping the witchcraft communities connected. Now witches can live anywhere in the world and connect with their fellow witches with the click of a mouse.

The witchcraft community is now composed of a dizzying array of practises and traditions. Wicca alone has nearly a hundred different variations. Because witchcraft has no central figure or body of authority, such as the Pope, the Dalai

Confidence, by Korvis

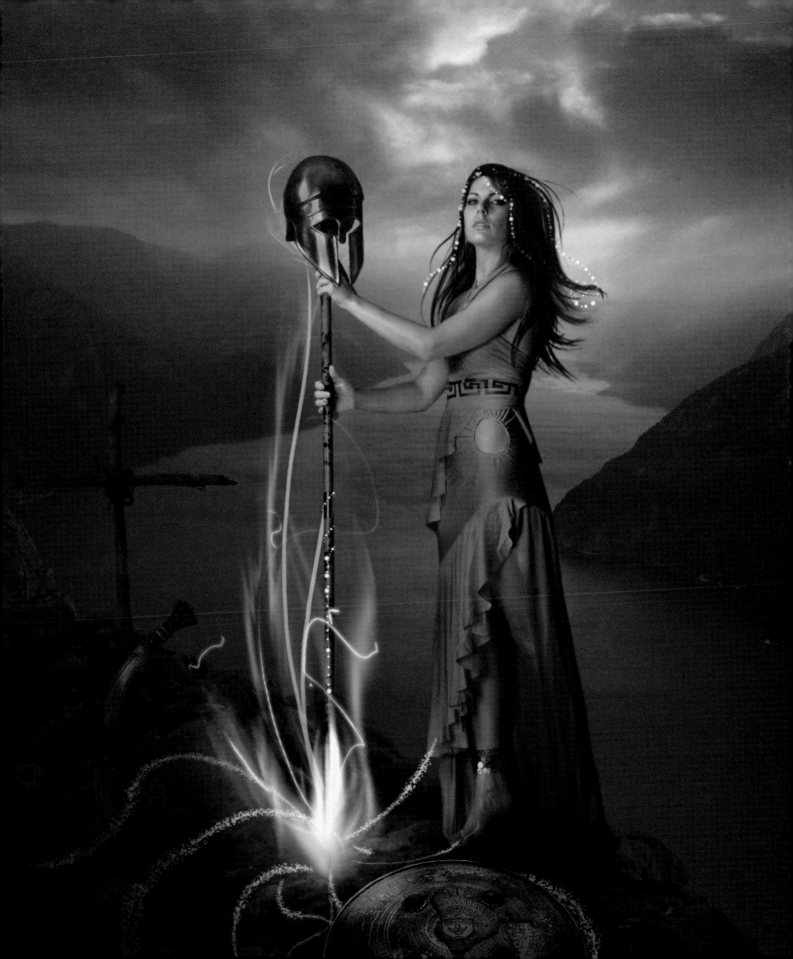

Lama or the Archbishop, every coven is pretty much autonomous and free to set their own rules, rites and rituals. This not only keeps the religion of witchcraft flexible, but it keeps it elusive. It is difficult for outsiders to get a firm handle of understanding on what is essentially a mystery religion.

Witchcraft in Pop Culture

It was around the mid 1990's that witchcraft began appearing with much more frequency in the themes of films, television, books and other media. In 1996 a film by Sony Pictures entitled *The Craft* became a hit sensation, particularly amongst young people. This began a trend that is still with us today. 1996 also saw the debut of a popular TV show called *Buffy the Vampire Slayer,* which featured heavy occult themes and a main character who was a powerful witch. The show lasted for seven seasons and spun off another successful series filled with occult themes entitled *Angel,* was based on the vampire character who was the former love interest of Buffy. *Sabrina the Teenage Witch, Blood Ties, The Highlander* and *Charmed* are just further examples of the popularity of occult and witchcraft themed entertainment, particularly in the United States.

But one can go further back to find examples of witches in film such as the classic *Wizard of Oz* featuring The Wicked Witch of the West who, despite being the villain, is considered the most popular character in the film.

Arguably the most successful and famous phenomenon in this genre in recent years has been the Harry Potter stories. With sales of the books in the millions worldwide and record-setting box office earnings for the films, the creation of author J.K. Rowling has practically redefined how the public views witchcraft.

Other areas of the media that have seen an explosion of witchcraft themes are the publishing world, comics/graphic novels and the world of computer games, such as *Dungeons and Dragons* and *Witch Hunter,* to name but a few.

All of this, of course, has had its negative effects, particularly when it comes to the church, religious leaders, school officials and concerned parents who see this vast interest as the work of the devil or at the very least, some evil organized underground conspiracy to undermine society.

For example, the wildly popular Harry Potter books have been burned, the films protested and boycotted by small but vocal groups who feel that the books contain evil spells and teach children how to be witches. Even the author has been accused of placing subliminal messages in the books and of being a witch herself.

All of this points to the fact that as a fantasy artist, there is a sizable market for witchcraft oriented artwork. Movie posters, book covers, graphic novels/comic books, art for games and even CD covers for the more darkly inclined Goth rock bands.

The possiblities in dark art really are endless.

Special Note: The magical writings, symbols and spells contained in this book are real. Do not attempt to work any magic or spell casting with them unless you know what you are doing. In some cases the spells or symbols are incomplete on purpose because many of the ancient signs and symbols contain power within themselves and can be activated by drawing them. If you are serious about learning more about these elements, do the research and work from your findings. However, be warned; opening certain doors can be dangerous.

Cerredwen, by Angella Barrett

Chapter One:
Basic Tools and Techniques

Workspace

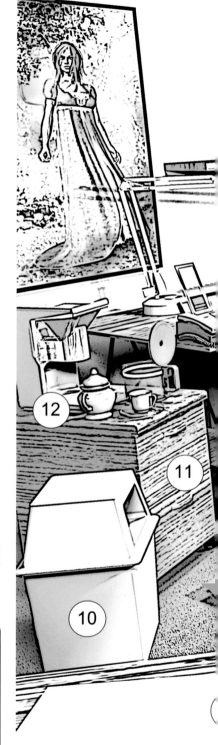

Your workspace need not be elaborate, but it should contain all the materials, tools, supplies and equipment you use in your work on a regular basis. Everything should be kept within easy reach, but in an uncluttered and organized fashion so that you don't have to go on a treasure hunt to find what you need.

Most artists like to decorate their studios and workspaces with objects, artifacts and artwork of their own or that of other artists. Posters, prints and original art by your favourite artists; plants, skulls, small sculptures, old books, candles… use whatever you can to make your working environment comfortable and inspiring.

Make sure you use a chair that won't put strain on your back or neck. You will be spending considerable time sitting in it, so it is important that it is comfortable and supportive. Use natural lighting whenever possible, but keep your work area well lit to prevent eyestrain.

Music can do wonders to create a relaxing, stress-free work environment. Classical music, ambient instrumentals or natural sound effects such as rainstorms, ocean waves or rippling streams are excellent for getting the mind relaxed and in a creative mood.

Take some time to work out the best environment for you personally, and what other elements you need to include for it to be conducive to creativity. It is important that you are comfortable in your surroundings and therefore are happy to spend many an hour in your studio creating your masterpieces.

As your work develops you will be able to identify what other tools or materials you will need to purchase. Detailed here as a guide is my personal studio set up, and the basic items that I have found I need in order to create my art.

1.	Drawing table	9.	Flat file/plan chest
2.	Comfortable chair	10.	Bin
3.	Drafting lamp	11.	Artist's taboret
4.	Natural light	12.	Coffee maker
5.	Reference books	13.	Phone/fax
6.	Computer workstation	14.	Lightbox
7.	Layout table	15.	Stereo/CD player
8.	Paper and boards		

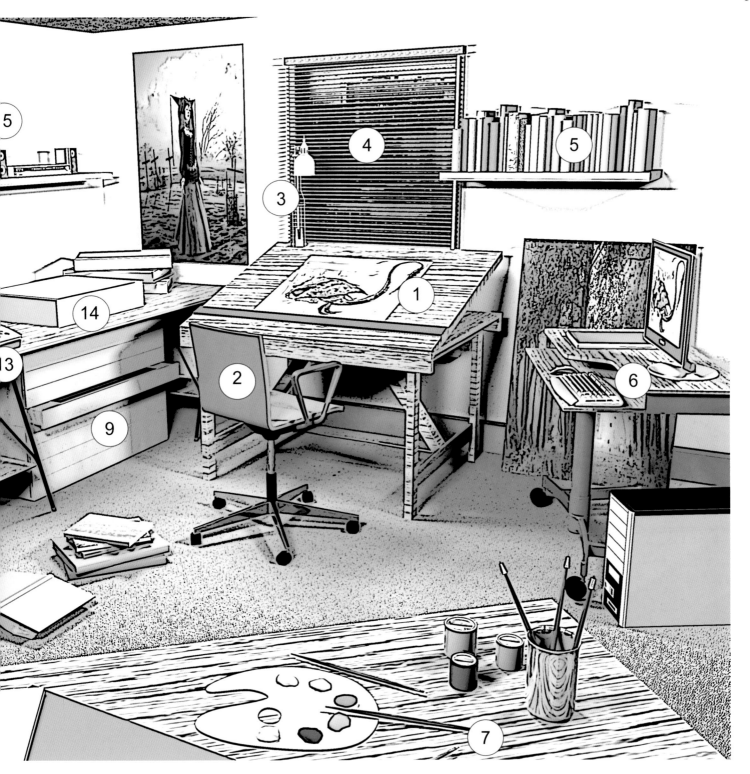

Materials and Basic Techniques

There is a huge array of artists' supplies, materials and equipment available. You can order supplies over the Internet, but nothing beats going to a store and experiencing the thrill of the smells and the range of materials available. You can't feel the softness of a camel-hair brush or smell the aroma of fine linseed oil through your monitor. Prices for supplies can range from the very inexpensive student grade to the very expensive professional grade. If you are just beginning as an artist, there is no need to break the bank buying all of the top-of-the-line materials. The student-grade materials will do well enough for you in the early stages of your education. As you master the craft you may decide to spend extra money on professional-quality supplies, but you will hopefully by then be in a better position to know exactly what type of equipment you need and also what suits your personal technique the best.

Pencils

Perhaps the most basic and under-appreciated artist's tool is the pencil. A pencil can produce a wide range of tonal values, lines and textures, and is capable of amazing things in the hands of a skilled artist. You can buy pencils individually or in sets. You have the choice of carbon, lead, charcoal, colour, watercolour and oil pastel pencils. The drawing pencil comes in various grades, from the almost charcoal-like 6B to the very hard 6H. Thus you can choose a pencil for light sketching or for heavy shading.

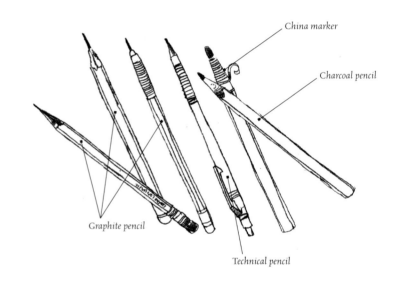

China marker

Charcoal pencil

Graphite pencil

Technical pencil

Basic techniques

Flicks	*Shading*	*Hatching*	*Crosshatching*
Short, directional lines that follow a shape, or the flow of hair, fur or grass. These can be heavily overlaid to form a dense texture.	A side-to-side motion that builds up an even layer of colour. A light touch deposits the faintest amount of pigment for graduated shading.	Rapid, regular, evenly-spaced parallel lines are drawn, leaving a little of the underlying drawing surface showing.	Hatching overlaid at right angles. This can be carried through to multiple layers, to create an effective texture.

Pens

Some beginning artists find pens intimidating because of their unforgiving nature. Despite this, ink remains one of the oldest mediums still in use today. Great artists of the past such as Leonardo da Vinci and Michelangelo left behind many of their ink drawings for us to marvel at their skill. Pens come in a range of different shapes and sizes, and each one creates a different effect, from the simple yet expressive quill to the more complex and expensive technical pen favoured by architects and engineering designers for precise, uniform lines. Technical pens carry their own refillable ink reservoirs, allowing for long, uninterrupted sessions of work. Other artists prefer using the common ballpoint pen or felt-tip pen. Make time to try out different pens, techniques and marks to find out which you like. But most of all, don't be afraid of it!

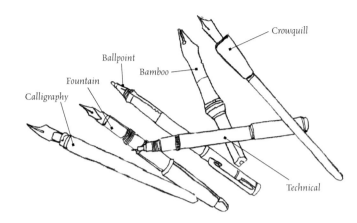

Basic techniques

Parallel Lines

Carefully draw a series of thin lines next to each other, as close together as you can without them touching. The closer the lines are to each other, the more dense the image becomes. This can be used for shading objects.

Broken Parallel Lines

A variation on the parallel line. Useful for simulating rain if you space the lines farther apart and increase the randomness of the broken lines.

Crosshatching

The most common form of ink shading. Simply create a series of parallel lines going in one direction then another series crossing over them in another direction. The tighter you pack the lines, the darker the shading becomes.

Stipple

This is a very time consuming technique, but the end result can be stunning. Using carefully placed fine little dots of ink, space them in such a way that you can simulate a variety of textures.

Papers and boards

The assortment of papers and boards available is wide and varied. Select the paper or board that you feel works best for you and your chosen medium. Experiment with the different types available if you are unsure of which to choose; the effects can be very different depending on the absorption of the board and the type of medium being applied, so it is vital that you make an informed selection.

Paints

As with all artist's supplies, paints come in an overwhelming range of options, each with a different technique. as ever, explore the variety available and experiment freely to identify what suits you best. Outlined below are just some of the different types of paints available today and their properties.

Oils are slow-drying paints consisting of small pigment particles suspended in a drying oil. **Gouache**, a heavier and more opaque medium than watercolour, consists of pigment suspended in water. **Egg Tempera** paints are made by binding pigment in an egg medium and produce a smooth, matte finish. **Casein** are a fast-drying, water-soluble medium. They generally have a glue-like consistency, but can be thinned with water to suit the individual artist. **Enamel** paints dry to a hard, usually glossy, finish. **Airbrush** colours consist of pigments that are ground finer than those in craft paints, allowing for easy use in an airbrush.

WATERCOLOUR PROPERTIES & USES

• A dry pigment bound by an adhesive such as gum arabic, and applied, greatly reduced by water, to a surface such as paper.

• Can be applied in a variety of ways, such as a *wash*, where the paint is loaded on to a brush heavily saturated with water and applied in sweeping motions to paper; *wet-on-wet*, where the paint is applied to an already saturated painting surface and allowed to bleed and spread; *dry brush*, where the paint is lightly applied with minimal water added almost like painting with a colour pencil; *glazing*, where colour is added in thin transparent layers, each layer applied over an already dry one, and *opaque* where the paint is applied with the minimum of water, usually straight from a tube.

• A demanding medium since mistakes are nearly impossible to correct. Can be revitalized and re-worked when dry by adding water or more wet watercolours.

ACRYLIC PROPERTIES & USES

• A fast-drying paint containing pigment suspended in an acrylic polymer emulsion.

• Can apply most of the same techniques as watercolour, such as *washes*, *wet-on-wet*, *dry brush*, *glazing* and *opaque*, with the exception that acrylics dry very quickly and cannot be revitalized after they dry.

• When dry, acrylics are waterproof and have a consistency similar to plastic. Special additives or mediums can be purchased to add to the paint to prolong its workability, giving it a consistency similar to oil paints. Acrylics can thus be used for techniques normally found only with oil paints, such as *impasto*, where the paint is applied thickly to the surface. You can create a work that looks similar to an oil painting in far less time.

• Due to its rubbery nature, it can be applied to more flexible substrates, such as canvas, without fear of cracking.

Brushes

Brushes are usually grouped into those used primarily for oils, those for acrylics and those best suited for watercolour. Take a trip to your local art store and peruse the brush selection there. Feel the difference in their bristles, and note the many sizes and shapes on offer. Each type is suited to a particular application, from tiny detail brushes to huge landscape background brushes and delicate fan brushes. Experiment with them and discover which ones feel comfortable and work best for you. Be sure to look after them, and they will last for years.

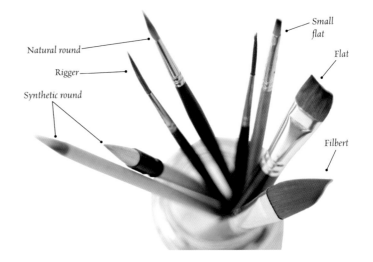

Natural round

Rigger

Synthetic round

Small flat

Flat

Filbert

Laying a colour wash in watercolour

The idea behind a colour wash is to add thin layers of watercolour over a pencil or ink drawing without obliterating it – all of your details should show through the colour. When working with pencil you should spray a fixative (obtainable at all art stores) over your work to prevent the water from smudging it. Don't spray too much or the watercolour will bead up – it is a good idea to practise on something other than your finished piece until you are confident. Permanent inks shouldn't need fixing as long as you don't soak them. Alternatively, scan your drawing and print onto good quality heavyweight paper or card stock, and then paint on that.

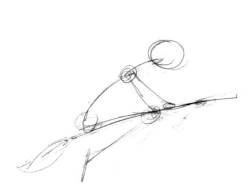

1. Begin with a rough pencil thumbnail to establish the basic pose of the figure.

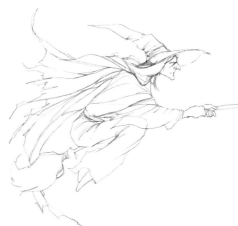

2. Define more clear outlines, erasing the sketchy lines as you go so that you don't confuse yourself.

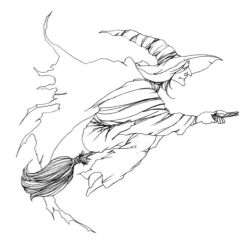

3. Now, add more folds to the clothes, grain to the broom handle and creases in the hat, continually erasing unnecessary sketch lines as you go.

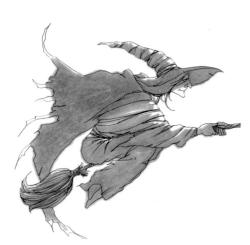

4. At this point, put in the basic grey shading to establish the mid-tone. From this it is established that the main light source is coming from the front of the witch.

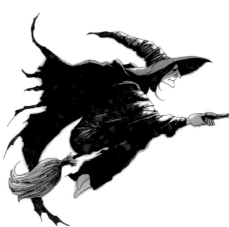

5. Now you can add the darkest darks. Since witches normally wear all black clothing, most of the work is done once you've put in the dark shading.

6. To finalize the image, add the skin tones, black shoes and a blue highlight to the upper edge of the cape, suggesting another light source above, such as a mysterious blue moon…

Computers and software

The digital age ushered in a new wave of creativity and forever changed the way artists work. Like the birth of the camera, computers have been both a blessing and curse to the modern artist. What once took weeks to create can now be done in a matter of hours with a few clicks of a mouse button. What you gain in efficiency and speed, however, you lose in the fact that when an artwork is completed there is nothing to hold in your hands or hang on a wall like a painting created on canvas. As such, computers have mostly dominated the commercial art world, where deadlines and the ability to make instant changes are more important than the aesthetics and longevity of the work created.

Computer-generated art can be divided into two main areas: vector art and raster art. Vector art is created using vector points and lines with software such as Corel Draw or Adobe Illustrator. This type of art is good for creating flat graphics that can be resized from the size of a stamp up to that of a billboard without any loss in quality. Raster art is made up of tiny pixels in such programs as Adobe Photoshop or Painter. These programs are good for manipulating photographs or creating digital paintings. 3D programs such as Maya, 3D Studio MAX, Lightwave, Cinema 4D and Softimage are used for creating ultra-photorealistic images, animation and special effects for motion pictures.

Creating computer art can be daunting: the programs are difficult to learn and master, expensive to purchase, and require updates or complete replacement periodically as new versions are released. The hardware that you need to run these programs can also be very expensive because you need powerful machines to handle the intensive memory demands. Consider carefully before purchasing computers and software. Buy the best computer you can afford, paying particular attention to RAM memory, the speed of your graphics card and storage capacity.

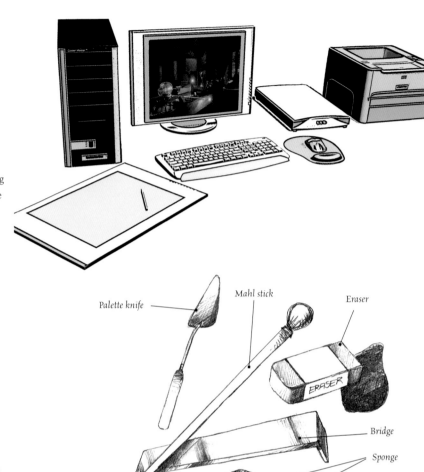

Palette knife | Mahl stick | Eraser

ERASER

Bridge

Sponge

Other equipment

Some of the other items you might find handy in your studio include the maulstick or the bridge, both used to keep your hands and arm off the surface of your work. Palette knives serve both to apply and mix paint, but can also be used to paint with. Sponges are useful for mopping up spills and applying interesting textures when dipped in paint. Erasers come in the well-known rubber form; the more plastic-like form for erasing ink lines from film, and the kneaded kind, which can be shaped to suit the job in hand such as erasing tiny pencil details without smudging the surrounding area.

A BEGINNER'S SHOPPING LIST

Buying art supplies can be overwhelming. There is so much to choose from! Below is a basic shopping list for beginners. As you become more familiar with the media, you can add to, eliminate or replace items.

• 10 acrylic paints, 10 oil paints, 10 watercolour paints (in small tubes), a small set of colour pencils
• 6 varied brushes for acrylic, 6 for watercolour and 6 for oil paints

• palette
• canvas panels or boards
• kneaded eraser
• 6 pencils from H to B range
• pencil sharpener
• palette knife
• 3 charcoal pencils
• sketchpad
• ruler or straight edge
• watercolour paper
• odourless turpentine
• small tabletop easel

Dark Art Research

No artist knows how to draw everything. At some point you're going to need reference materials, and these require research. To ensure that your imagery is believable, you must strive for accuracy. There are plenty of experts out there on any given subject, and they will not hesitate to point out your mistakes. To avoid this sort of thing, which can not only be embarrassing but can be detrimental to your professional reputation, always include thorough research in your creative process.

Books

Check out the art section of your local bookstores and libraries. You'll find a wealth of information on the various aspects of art, techniques, art history, biographies of artists, materials, equipment, advice and so on.

Other artists

Networking can lead to establishing professional as well as personal relationships with other artists. By attending art shows, participating in group exhibits, joining clubs and professional organizations, you can get to know other artists and share with them on a creative level. It's also a comfort to have someone to talk to who understands what it means to be an artist.

Museums and galleries

Nothing is more inspiring than looking at the original work of other artists. From the paintings of the celebrated masters of the past to the innovative works of contemporary artists, seeing what others have done can often generate ideas for your own work.

Magazines

There are many publications on the market that cater to artists. Some offer practical information on subjects such as techniques, materials and marketing. Others focus solely on the world of fine art, by profiling artists and their gallery openings. There are also magazines that explore a specific area of the arts, such as airbrushing or watercolour painting.

Experts

Subject matter experts are invaluable when it comes to researching something very specific or exploring an area that is totally unfamiliar to you. These experts can be found in phone books, at a local college or university, on the Internet or even in your own circle of family, friends and business associates.

The Internet

The World Wide Web has become one of the most influential inventions in the modern world. An extensive amount of information is literally at your fingertips 24 hours a day. However, due to its free and open nature, the information can be unreliable. If you do use the Internet as a resource, try to double-check the information with reputable sources.

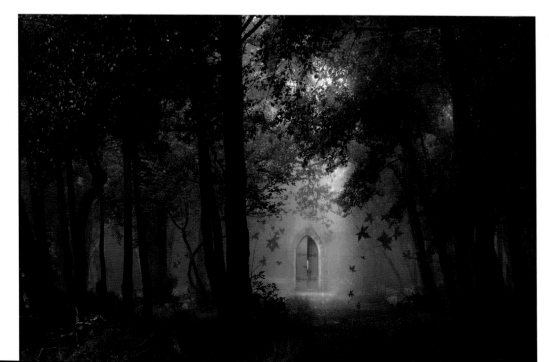

Mystic Wood by Angela Barrett
Using a limited palette of perhaps only four colours, Barrett creates a moody piece that is both haunting and beautiful. Deep in a dense, dark forest a clearing emerges, revealing a mysterious, ancient building bathed in sunlight. The path leads the viewer up to the door, the only brightly lit part of the picture and thus the main focus. Mist blankets the area around as the great oak door opens, daring the wanderer to enter.

Constructing a Figure

Ever since man first began drawing on cave walls, the most fundamental element in art has been the human figure. The human figure has played a dominant role in art history, from the artworks of ancient Egypt and the marble sculptures of the Roman Empire to the wondrous paintings of the Pre-Raphaelites and the digital works of today's young artists. As human beings, we can relate to and connect most easily with images that display other humans engaged in an emotional moment, everyday activities or a dramatic event. Being able to draw and paint the human figure is the foundation of any artist's repertoire. When drawing or painting the human figure, there are some basic areas that an artist should become familiar with and continually strive to master, as discussed below.

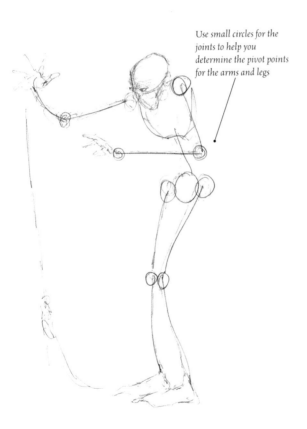

Use small circles for the joints to help you determine the pivot points for the arms and legs

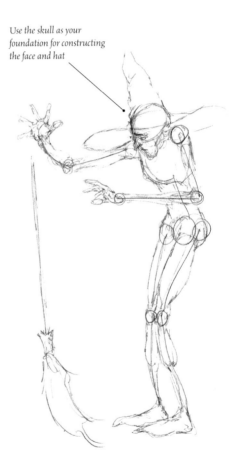

Use the skull as your foundation for constructing the face and hat

1. Stick figure

Start by constructing a stick figure thumbnail sketch to establish the general pose of the figure and broom. This is much like creating a skeleton upon which you'll construct the body.

2. Basic construction lines

Next, refine the outline of the body, the broom and the hat a bit more. Add the basic construction of the limbs and torso, using reference photos of the human body if needed.

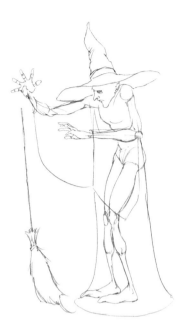

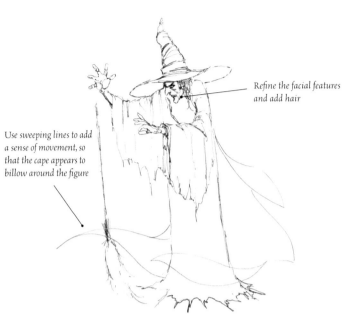

Use sweeping lines to add a sense of movement, so that the cape appears to billow around the figure

Refine the facial features and add hair

3. Clothing outlines

Using references for cloaks, robes and capes as a guide (see page 36), outline the basic shape using the figure as your guide for how the clothing will hang.

4. Further pencil line detail

You could add another guideline to mark where you want to include a flowing cape swirling around the figure.

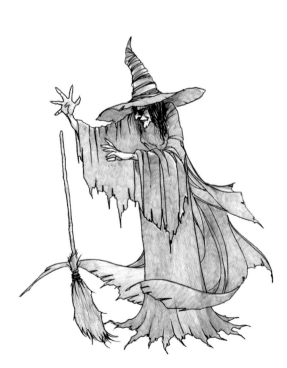

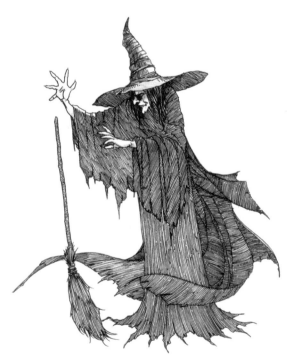

5. Shading for volume

Here's where you introduce the basic shading of the figure and broom. Using a number 2 pencil, apply shading to build up shape and textures and to establish the direction of the lighting. Also add more details to the hair, face, hands and broom handle.

6. Inking

Finally, texture the figure using various types of hatching and crosshatching to build up the form. From here, you can either leave the image as a clean ink rendering, add watercolour or scan it and add digital colour.

Constructing a Face

It is important as an artist that you can draw a face both front-on and in profile.
Here, you will learn how to do both, together with that vital accessory for dark art:
the witch's hat.

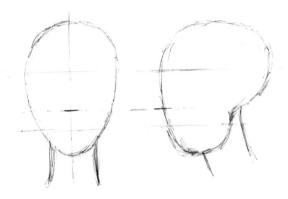 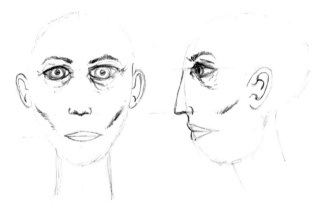

1. For the portrait or frontal view, draw an inverted egg shape and sit it atop two parallel vertical lines which will become the neck. For the profile view, draw something that looks like a fat 'P' shape, sitting atop two parallel lines that will form the neck.

2. Now add two circles for the eyeballs and sketch in the lips and ears. Use the guidelines to position the features, as shown above. Add extra detail to the eyes to make them look more realistic. Do the same for the ears and add light indications for the cheekbones.

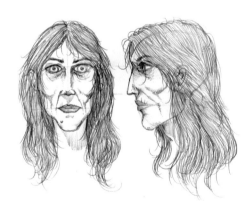 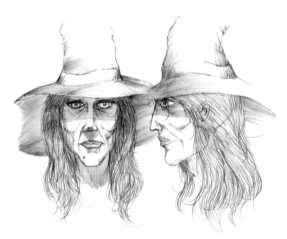

3. Begin to fill in the strands of hair with plenty of sweeping parallel lines, but don't have them all going in the same direction. Vary them by having a few go off in an odd direction, curling some and shaping a few into long waves. Look at the hair of a real person or the picture of a model in a magazine to get ideas on hair styles. Pick a style to suit the character – if you are drawing an old witch, as shown above, make the hair look untamed looking and dark in colour.

4. To finish the witch, add a conical hat (see page 37), some wrinkles and a wart. Also refine the eyes a bit more by adding heavy dark eyelids, texture the lips to look cracked and dry and add shadows cast by the hat brim and under the chin. This gives that extra push of realism.

Poses and Movement

If your figures are to have life and look realistic, they must stand and move like real people. Study people around you, taking note of how their bodies move, stand, sit or lie down. Practise sketching figures at a beach or take a life drawing class.

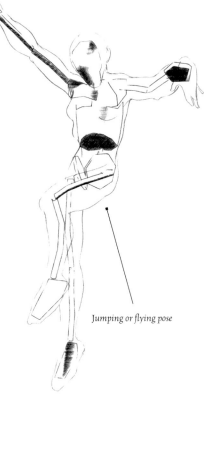

Jumping or flying pose

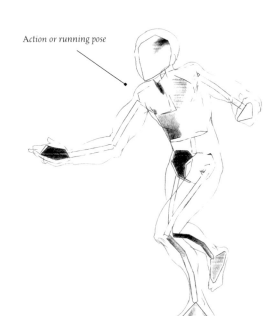

Action or running pose

Basic standing pose

Resting or seated pose

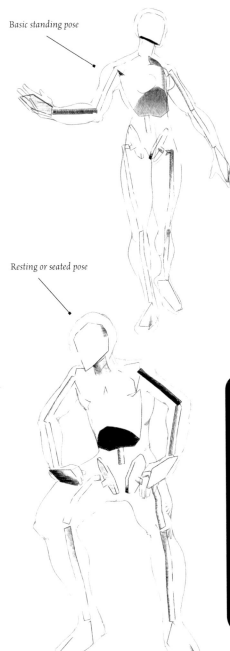

OTHER SOURCES OF GUIDANCE

Books

There are plenty of books available on human anatomy, many of which are written specifically for artists. There are picture books that offer numerous images of people of all shapes and sizes, ideal for those who don't have access to a live model.

Magazines

Model, fitness, photography and clothing magazines are all sources for images of human figures.

Internet

Just do a search for pictures of people and you'll find free images as well as online clip art services that offer copyright-free professional-quality photos of people for a price.

CDs/DVDs

Several companies offer photo collections of people posing specifically for the use of artists. These can be found in stores that sell software or online.

Poser software

A useful Curious Labs software program offers 3D virtual figures that can be posed like humans, altered to reflect races, sizes, shapes and ages and clothed in any fashion.

Life drawing classes

One of the fundamental educational experiences for the artist since the days of ancient Rome.

Tone and Texture

Learning how to depict various tones and textures will add a significant level of detail and realism to your work.

Texture is all about the surface quality or appearance of a work. Texture can be experienced by the senses of sight and touch. Consequently, it can be simulated by the artist through making a piece of art look as though it is textured in some way, or by actually adding texture through the use of materials such as sand.

Tone basically comes down to how light or dark a colour is. Every colour can produce a wide range of tones; how light or dark these tones are depends on the colour. Some of the more common tones are illustrated below:

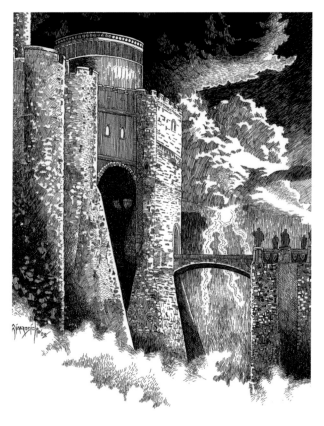

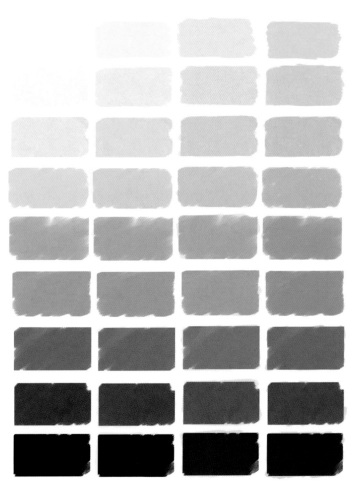

Tone

It's important to understand that tones are relative. That is to say, that how dark or light they seem depends on what other colours are around them. A tone that's obviously light in one composition may seem darker in another if it's surrounded by tones that are even lighter. The range of tones that can be produced varies as well. Lighter hues (such as orange) will produce a smaller range of tones than darker ones (such as black).

If a painting is going to be successful, you must get your tones right, otherwise all you end up with is visual chaos. The first step to doing this is to remove colour from the equation. You can do this by composing your picture in only black and white before introducing color. If your picture works in only black, white and shades of grey, then it will work in full colour.

Dark art, by definition, tends to use mostly dark colours and tones that evoke a sense of moodiness, despair, uneasiness, horror and mystery. However, dark art does not necessarily only refer to the colours used, it also refers to the subject matter. Many dark art pictures can employ a wide range of colours including bright yellows, oranges and reds, used to depict objects such as flaming candles. Dark tones can still be included in the picture in the form of long cast shadows, deep shading and perhaps a night sky. You can use the dark colours to serve as a contrast, adding drama to the scene.

Illustrated left are some of the colours and their tonal scales that are used in creating dark art.

Texture

When planning a work of art, the importance of texture should be considered in relation to the other major art elements, such as colour and tone. When used skillfully, texture creates contrast, stimulates the senses and can give a composition both unity and variety. Dark art employs a great many elements of the ancient and antique, so rough textures, cracked surfaces, wrinkles, creases, rust, dents and scratches appear often. Texture comes into play when creating elements such as gravestones, which need to simulate the hard, cold feeling of granite. Creating textures in pencil is not difficult to master. Observe the textures that surround you everyday and try to duplicate them on paper. Become familiar with the various types and grades of pencils and how they appear on paper. Practise drawing, sketching and shading using a variety of techniques. Here is a sampling of the various textures you can create using pencils:

Hair

Similar to creating grass textures, however, hair is usually styled in some fashion. Start with soft sweeping lines that are nearly parallel to each other with some slight variation in width. Group hair strands together as they go in slightly differing directions, plus a wild hair or two to makes it look more natural. Shading also comes into play as upper hairs cast a shadow on hair below.

Fur

Similar to drawing hair, but with shorter strands that are somewhat stiffer in shape. Fur can be considered to have a texture that falls between grass and hair.

Metal

The key to drawing metal is to remember that metal has no colour. Instead it reflects the world around it. In the sample shown right, the lower half is dark and the upper half is light because the lower half is reflecting the ground and the upper half is reflecting the sky. This basic combination can be altered in infinite ways depending on the objects that are being reflected. Add a warp to the shape of the colour to further enhance the perception of a metallic object.

Stone

Here you can use an infinite variety of shapes since rocks and stones are naturally formed and no two look the same. You can have large heavy boulders, small shards of rock or tiny pebbles. You can even mix them up as you might see at a rock quarry or at the foot of a mountain. Use lots of texture and shading to enhance the sense of weight and hardness.

Glass

Like metal, glass, particularly clear glass, has no colour. Not only does it reflect the shapes and colours of objects around it, but you can see through it, so the colours of the glass are affected by what you see on the other side. This sample shows the white space behind the wine glass, while the warped shapes and sweeps of shading on the glass suggest reflected objects, including any nearby lights.

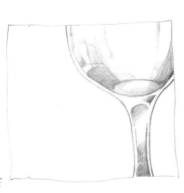

Bark

Here the pencil is used to create a hard, rough and brittle texture. There are numerous varieties of bark just as there are many types of tree. Take a trip to the woods and study the tree trunks and the fallen branches.

Colours

The proper understanding of how colour works is extremely important to the artist. Colour is what brings your artwork to life, and knowing how colours interact with each other, complement each other and contrast with each other enables you to add one of the key elements of realism to your work.

Warm and cool

Warm colours are reds and yellows. Cool colours are blues and greens. A cool colour palette increases the sense of distance. Cool colours are recessive while warm colours advance into the foreground.

Primary

There are three basic colours that are in their purest form and cannot be created by mixing any other colours. These are red, yellow and blue. Together they are called the primary colours.

Secondary

The secondary colours are produced by mixing together two primary colours. If you mix red with blue you get violet, red and yellow produces orange, while yellow and blue renders green.

Tertiary

Next come the tertiary colours, which are produced by mixing a primary with a secondary colour. These colours are: red-orange, yellow-orange, blue-green, blue-violet, red-violet and yellow-green.

Complementary

Complementary colours are those on the colour wheel that lie opposite each other. When mixed in the proper proportions they will produce a neutral colour (grey, white or black).

Digital

When working digitally, the two main groups of colours used most often are the RGB colors and the CMYK colors. RGB colors are formed by the precise mixture of the colors Red, Green and Blue in various percentages to create a full spectrum of colors. RGB colors are those used for the images you see on computer screens and television sets – colours formed with light.

CMYK refers to the colors Cyan, Magenta, Yellow and Black. These are the colours associated with printing. The precise mixture of these four colours creates the millions of colors used in the print trade or your desktop colour printer. When you create a digital work of art for print, make sure it is saved in CMYK format. If the image is to appear on the internet or sent in an email to be viewed on a computer screen, make sure it is in RGB format.

Colours for Dark Art

The best way to paint is to use a limited palette; you will be surprised at how much you can do with just a few colours. The standard palette would cover the basic colour wheel, featuring the three primary colours (yellow, red and blue), the three secondary colours (green, orange and violet), black and white. From these eight colours you can experiment to create all the colours there are, along with their hues and tints. Dark art favours darker, cooler and earthy colours.

Ghost Witch

You can use whatever shade of blue you prefer. The black is mixed with the blue to bring its tonal value down for darker blues. Black mixed with the white provides the mid-tone greys. White mixed with the blue creates a lighter tint of blue. White used alone is for the highlights and mist.

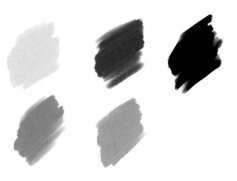

Mystic Wood

Here is a case where a limited palette can create a wonderfully rich painting. The black and white mixed with the sepia and olive green in various degrees gives a full range of tones to create the many layers of leaves, the ground, the stone building, the wood door and the misty fog. Your eyes may trick you into thinking you're looking at many more colours than there actually are. This is an example of a well planned working colour palette and expert use of it. the other colors for shading and shadows.

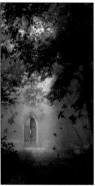

Celtic Druidess

Green plays the dominant role in this painting since it has a Celtic subject. The Celtic Druidess is very connected to nature, more specifically the forest, so use earthy colours. White with red gives the pink for the skin. The sepia, orange and black give the tones of brown for her hair, the staff and her shoes. The blue is mixed in with the green to give variations in tone. Black is used with the other colours for shading and for shadows.

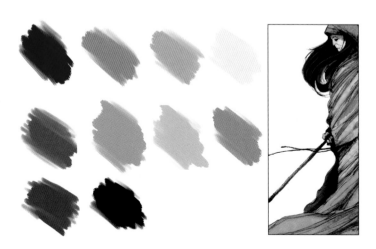

Perspective

Perspective is a fundamental technical skill that must be mastered if you want to add realistic depth and dimension to your artwork. Whether you are drawing a castle, a room interior or a set of candles on a table, perspective is that mysterious and often hard-to-understand element that puts objects in proper relation to each other and their environment.

One point perspective

To understand the fundamentals of perspective, begin by drawing a horizontal line from the left to the right side of your paper about a third of the way up from the bottom. This is what is called the horizon line or eye level. Above that line is the sky while below it is the ground.

In this demonstration, a group of low two-storey buildings have been created. Their left side with all the doors and windows seems to get smaller and smaller as it approaches the horizon line. Invisible lines extend from all the shapes (windows, doors, bricks, etc.) of the building to a central point on the horizon line, which is called the vanishing point.

In this case, parts of the buildings face you while the other parts fade back to the one single vanishing point. This is called one point perspective.

Vanishing point

Horizon line

Two point perspective

In this scene we have two vanishing points with two sides of the building and other structures receding in two different directions. The corners of the objects face you directly. Because there are two vanishing points, this is called two point perspective.

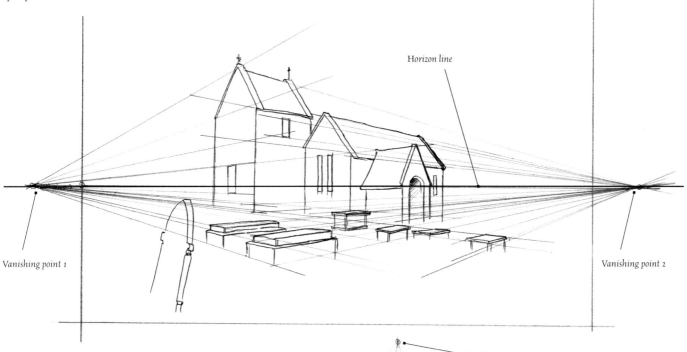

Horizon line

Vanishing point 1

Vanishing point 2

Vanishing point 3

Three point perspective

As the name suggests, this scene will have three vanishing points, but only two will be on the horizon line. The third will extend either far up into the space or down towards the center of the earth. This is the type of exaggerated perspective that is useful when showing the view one might have if looking straight up the wall of a castle tower or deep into a dungeon.

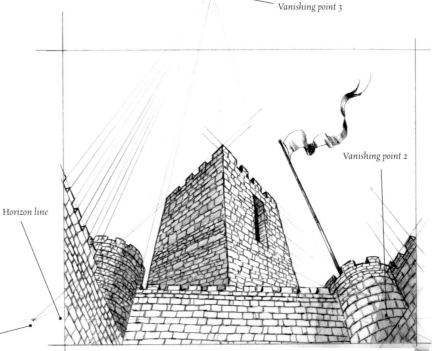

Horizon line

Vanishing point 2

Vanishing point 1

33

Composition

Composition involves the placing of the elements in your drawing or painting and dividing the space to achieve an aesthetically pleasing balance and movement for the eye. The size, shape, colour and texture of the objects in your work determine how they are placed in the scene. The composition can directly affect the mood or feeling that will be invoked in the viewer.

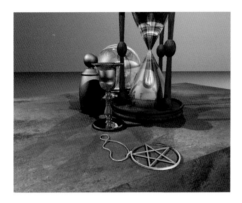

Tight grouped arrangement
The larger objects are bunched together in the background. The pentacle, dominating the foreground, is the main focus. The empty space to the left is unsettling as it seems something should be there, which throws the picture off balance.

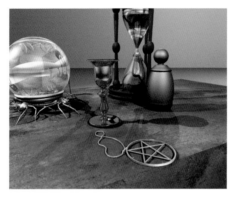

Triangular arrangement
The objects are placed so that you can almost see a triangular shape around them. The pentacle, alone in the foreground, dominates the composition. The cast shadow from the chalice leads the eye back from the pentacle to the objects behind.

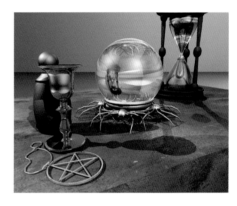

Stepped arrangement
The objects increase in size and weight from front to back. The crystal ball dominates due to its light colour and circular shape. Your eyes are drawn to it immediately as the main focus, with the pentacle a close second due to its forefront position.

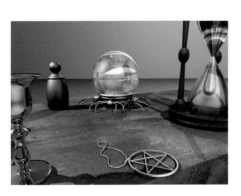

Wide spread
The objects move around the space in a circle that appears too wide. The chalice is leading out of the picture and the pentacle is hanging off the edge of the altar, too close to the bottom. The empty space in the middle makes the picture seem incomplete.

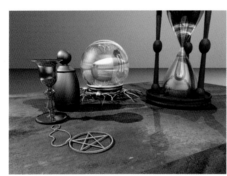

Circular
This leads the eye in a circle, starting at the hourglass and moving left as the objects reduce in height to the pentacle chain, which leads the eye around to the pentacle itself. The pentacle's star and the chalice's shadow point back to the hourglass.

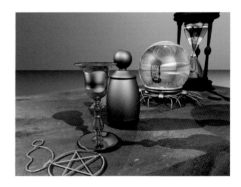

Static stepped arrangement
With the lightest object in the foreground and the largest, heaviest object in the background, this composition is too static and arranged. The objects are placed almost as if comparing sizes; very uninteresting!

Lighting

Lighting is an elusive and challenging aspect of an artist's learning process. It may take many years of work, experimentation and study to fully understand how light affects the scenes you create. Light can be natural, artificial, bright, dull, clear, misty, warm, cool, intense or subdued. Light creates mood, establishes the time of day, adds realism and controls the visibility and colour of the objects in your scene.

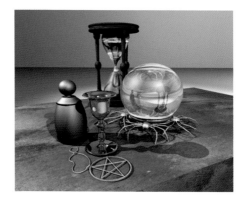

Even light
Two or three lights placed around and above the objects cause shadows to appear, each going in a different direction. Even light allows all sides of the objects to be illuminated, invoking a peaceful mood.

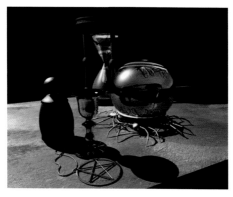

Single backlight
One strong light to the rear casts the shadows foreward and obscures the fronts of the objects. The long dark shadows add a sense of mystery. This could be light coming from a moon outside a window or from a door being opened across the room.

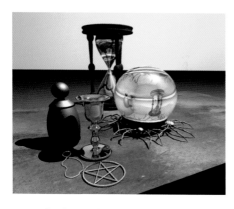

Single frontlight
The opposite of the backlight, the single frontlight illuminates the front of the objects, sending the shadows to the back. This creates a dramatic mood.

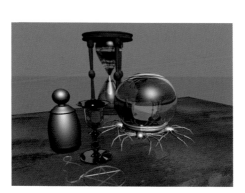

360° light
The objects are equally illuminated from all sides by an ambient light with no clear single source. There are no shadows to add contrast, so a dull, somewhat dead picture is created.

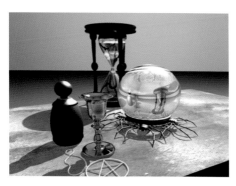

High spotlight
The objects are lit from high above by a single strong light, casting shadows off to the left. As the light bounces off it, the glossy details of the crystal ball are highlighted. The top of the altar looks hot in the glare. Creates an energetic, anxious mood.

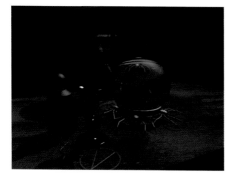

Subdued light
Only a hint of blue light illuminates the scene invoking a quiet mood, as if the objects are seated below a starry night sky. The shadows are fuzzy and only small points of the metallic and glass objects are highlighted.

Chapter Two: Tools of the Trade

Clothing and Accessories

To clothe your witches, wizards and sorcerers in a realistic fashion, research the costumes of the particular period and culture and the social status of the character you have chosen. Centuries ago, witches in western Europe tended to be of a lower social class, so wouldn't have been able to afford the fine silks and furs that were worn by the wealthy aristocrats. Centuries on, the style of clothing has changed. Aside from the various articles of clothing specifically related to the craft, witches and sorcerers can now wear pretty much what everyone else wears.

Accessories

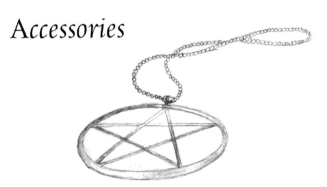

Pentacle amulet
Controlled by the invisible forces of the universe, this amulet shielded the wearer from evil. It was worn for good luck and was normally inscribed with the names of the gods, magical words, numbers or symbols.

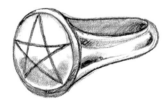

Pentacle ring
These were talismans of magic inscribed with spells, inscriptions or symbols to ward off evil, for protection or for divinity. A magical circle representing eternity was said to contain the energy or power of the wearer. It was also worn for recognition by other witches. In many ways it has the same meaning for witches as the wearing of a crucifix has for Christians.

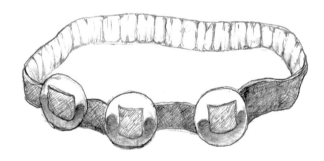

Garter
Worn by the high priestess as a symbol of rank, the garter was normally green with a blue silk lining. It was made up of one large silver buckle, which represented the priestess' own coven, and smaller buckles for each of the other covens under her jurisdiction. The garter was worn on the left leg above the knee.

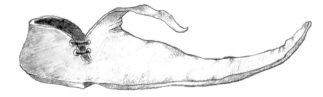

Poulaine
This is a style of shoe with extremely long toes. They were worn by both men and women from around the end of the 14th century to the late 15th. The men's shoes normally had longer toes.

Headwear

There are many forms of headwear worn by magic-makers in various cultures around the world. Some are worn as part of a particular ceremony, while others are worn as badges of office, such as in the priesthood of certain cults and traditions.

Drawing a witch's hat

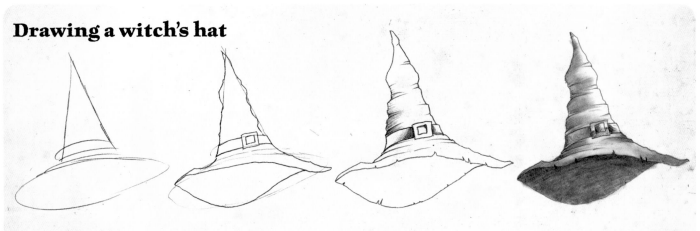

1. Start by roughly sketching a cone with an oval shape at the bottom, which will become the brim.

2. Next, refine the cone to give it a slightly more wrinkled look and a slouching shap. Add curves to the brim to make it look less rigid and to give a good three dimensional angle andperspective.

3. Refine the image further, adding more wrinkles and making the edges of the brim look tattered. Add the band and buckle on the hat. Give the band a scratchy texture and the buckle a tarnished shine.

4. Apply shading. Select a light source coming from the upper right side, so the shadows will be on the left side of the hat. The underside will have the darkest shadow where no light is reaching. To make it look old and worn, apply pencil lightly and smudge.

Other hats

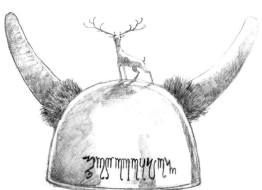

Wicca High Priest helmet
This helmet was worn at rituals where the priest represented the Horned God.

Wicca High Priestess headband
This headband was worn at rituals where the priestess represented the Goddess. It features a silver crown or a band with a silver moon at the front.

Tibetan Shaman's headdress
This ceremonial hat was worn in Tibet in dance rituals to drive out demons and to appease good spirits.

Wands and Staffs

No witch or wizard is complete without a magic wand or staff. These have long been held as key elements to witchcraft and sorcery in centuries of old folklore and fantasy.

The wand is a personalized tool created by the witch, and is perhaps one of the most important tools. Wands are usually made from elderberry, willow, rowan, hazel, oak or mistletoe. These woods are considered to be sacred to the deities. A wand can also be made of glass or metal if the witch prefers. It is often inscribed with magic symbols, adorned with crystals and the witch's craft name. The wand is used in spellcasting and rituals to channel focused energy.

The staff, which is mainly associated with wizards, shamans and sorcerers, is a large stick symbolizing wisdom and power. Like the wand, it is used to amplify magic and sorcery. A staff is also used to fight demons and in the casting of circles. One of its more practical uses is as a plain old walking stick or a weapon of defence.

A variation on the staff is the witch's stang. This is a staff with a forged or pronged end formed either naturally or with an extra branch tied on. A stang is usually made of ash wood. It can serve to sanctify an area as a temporary altar. Stangs are also used as a staff of office for the coven Magister or Magistra.

When illustrating a wand, make it about the length of the witch's forearm. Staffs and stangs are normally about the height of the figure using them. Give them a natural gnarled wooden appearance with textures appropriate to the type of wood used.

Drawing a witch's staff

Note: You don't necessarily have to use a human skull. The skull of an ox, deer, cat or even a bird can be used. Horned animals or animals with long fangs lend the staff a more fearsome look.

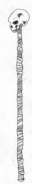

1. Roughly sketch a long pole and the rounded outlines of what will become a skull. Keep the shape of the pole irregular since staffs are usually either carved out of wood by hand or made from a long naturally shaped branch.

2. Next, refine the outline a bit more and give the skull more definition. It's a good idea to work from a reference source. Unless you happen to have a human skull lying around the house, there are plenty of reference photos on the internet, in medical journals or in old books on anatomy.

3. Add wrappings to the staff, which would normally be made of something natural such as leather. Keep the wrappings irregular and overlapping to give it more of a hand-made look. Top it off by adding more details to the skull.

Other witch's staffs

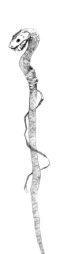
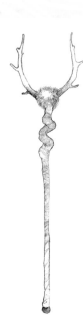

Witch's stang
With a forked or pronged end, made of ash wood, often used as a staff of office for a coven Magister/ Magistra.

Snake head staff
A healing wand symbolizing the serpent that coiled around the staff of Asclepios, the Greek God of Healing.

Stag horned staff
A staff for a male witch or wizard, the antlers representing the Horned God.

Wands

Ivory
Used by more wealthy witches for ceremonial rituals.

Ebony
Custom made for more affluent witches, used for symbolic scourging.

Leather-wrapped
Wrapped in animal skin, a magic stone fixed on top. Used for spellcasting.

Natural willow
Made from a broken willow branch, chosen for its unusual shape. Used for spellcasting.

Jewel
Made of natural wood, a magically consecrated stone or jewel fixed on top. For spellcasting and evoking spirits.

Coiled
A naturally twisted wooden wand, used for healing, as its snake-like appearance is reminiscent of the Greek God of Healing, Asclepios.

Shaman's staffs

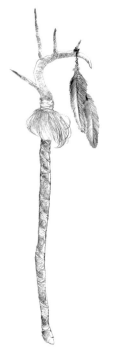
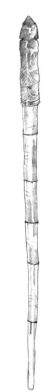
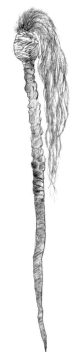

Antler
Echoing the design of Native American Shamanic traditions, the antler and feather represent animal totems. Used for summoning spirits.

Batak Shaman's
Shaman from Sumatra used these ritual staffs, also called 'tunggal punaluan', which feature a carved figure on the top.

Horsehair
Used by Native American Shamans or medicine men in healing rituals.

Garments

Cloaks or capes were worn by many magical people, including magicians, sorcerers and wizards. Today, most modern witches still wear hooded cloaks at rituals, gatherings, sabbath observances or even around the house.

Drawing a witch's cloak

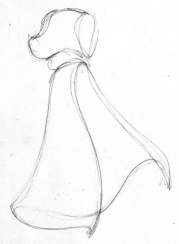 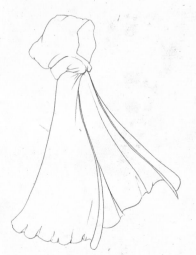 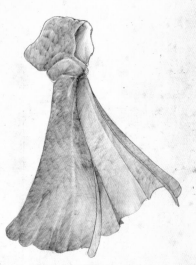

1. To begin, lightly pencil a rough sketch to work out the general design and pose for the witch's cloak. To make the cloak loose and flowing, use long, sweeping motions to draw the lines. As the shape becomes more clear, the pencil lines will become gradually darker until you have the shape you want.

2. Lay a sheet of tracing paper over the rough sketch and further refine the shape adding folds and creases. Transfer this to your paper and continue refining. Alternatively, if you have a light box you can transfer the rough sketch directly onto the final paper and then refine.

3. Finally, add shading to give the cloak weight and substance. Use finger smudging to give the texture a heavy, rough (but not too rough) appearance...like that of a heavy fabric. Shade the inside of the hood so that the front edge is lighter to give depth.

Highwayman's coat
This style of coat was popular amongst 'Highwaymen', a term used during the 17th and 18th centuries to describe criminals who robbed travellers. It may also have been worn by male witches, warlocks, and witch-hunters.

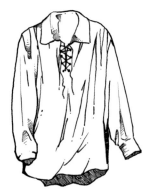

Poet's shirt
This was a popular style of shirt for men during the Renaissance period. Today it is back in popularity among male witches, those who either work in or visit Renaissance fairs, or men who just have a romantic flair.

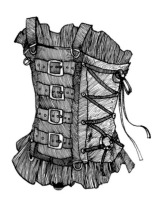

Goth's corset
This is a very popular garment in the modern Goth underground, but is also worn by Renaissance re-enactors and witches who have a leaning towards the darker lifestyle of the Goths.

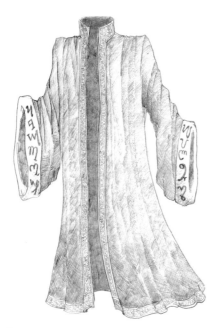

Sorcerer's robe

A non-hooded version of the cloak, this would have been worn largely by male sorcerers and wizards; it was mostly a badge of office or a uniform and was worn all the time rather than just for ceremonial purposes.

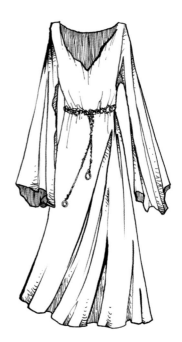

Silk gown

This type of gown lends a touch of elegance to your character. It is perfect for dressing a witch of the faerie tradition or a Celtic witch. It can be any colour you like with various trimmings. It can also be adorned with magic symbols or Celtic knotwork.

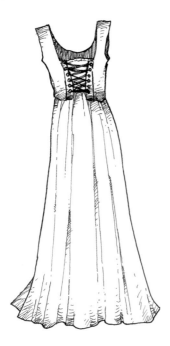

Gypsy outfit

The Gypsies are a nomadic culture that originated in India during the Middle Ages. Some legends claim that certain Gypsies have magical abilities. Today there is a Gypsy tradition of witchcraft. This outfit is a popular style associated with Gypsy women and worn by witches and those who attend Renaissance fairs.

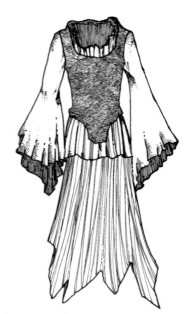

Medieval Avignon dress

This elegant style of dress is a favourite among modern witches who like to dress with a medieval flair when attending rituals and gatherings. Avignon is a city in southern France, well known for its Palace of the Popes, where several popes and anti-popes lived from the early 14th to the early 15th century.

Other Dark Art Tools

Two of the more well known witch's tools include the broom and the cauldron. The broom was a witch's preferred means of transportation, while the cauldron served as both a pot for cooking meals as well as a vessel for the preparation of potions and spells.

Brooms

Drawing a witch's broom

The witch's broom, also called a besom, is one of the most well known elements of the myths and legends of witchcraft. Most of us recall watching the *Wizard of Oz* and staring in wide-eyed wonder when the Wicked Witch of the West took off on her broom. Modern audiences now stare in wide-eyed wonder at Harry Potter when he takes off on his significantly upgraded version of the flying broom. Whichever one you prefer, the broom remains the primary mode of transportation for witches.

Note: If it helps, find a photo or a real broom or besom to use as reference.

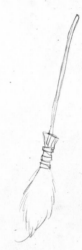
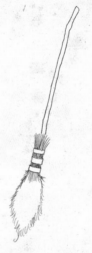
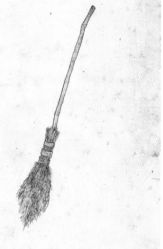

1. Begin by sketching out a long, thin pole shape with a wide brush shape at the end. Sketch in the bands that hold the brush to the pole.

2. Refine the linework, deliberately making the broom stick a bit crooked. Most traditional besoms were made of naturally formed branches or roughly hewn wood poles. Draw in the strands of straw and tighten up the binding strips.

3. Finally, add texture to the broom handle and finer details to the brush and binding strips. Then take her for a ride!

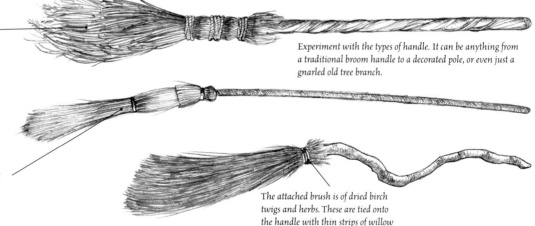

Force yourself to look at the shapes between the branches on the broom and use a pencil to shade in these areas

Experiment with the types of handle. It can be anything from a traditional broom handle to a decorated pole, or even just a gnarled old tree branch.

As you draw, you will become aware of the decorative nature of the patterns that are made

The attached brush is of dried birch twigs and herbs. These are tied onto the handle with thin strips of willow

Cauldrons

Drawing a cauldron

Life first came from the cauldron in the form of food. Now said to represent the cosmic womb, it offers infinite sustenance, bringing life to rituals and spells. Cauldrons are basically rounded pots with or without a lid. Normally made of heavy metal such as cast iron, they can come in a variety of sizes.

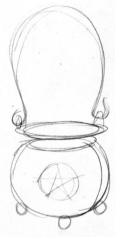

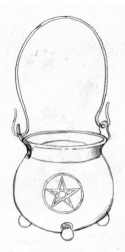

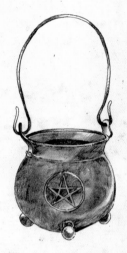

1. Roughly sketch a large circle for the main body of the cauldron, and two ovals at the top of the circle, which will form the lip and opening. Place three small circles along the bottom edge of the circle for the feet and add an simple, elegant curved handle at the top. Rough out a small pentacle symbol on the front of the body.

2. Using tracing paper or a light box, do a series of sketches, refining the image as you go until you have a clean outline of the cauldron.

3. Begin shading with a thicker pencil such as a 4b, 5b or 6b. Make the cauldron appear heavy, beaten up and blackened by constant use. Give it a bit of a shine to enhance the sense that it's made of metal. Why not put whatever witchcraft symbol you want on the side, using shading to make it appear three-dimensional?

Celtic
There are many famous cauldrons in Celtic legends. The cauldron of the Dagda was one of the treasures of the Tuatha Dé Danann.

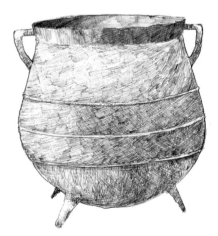

Ancient cast iron
Typical potbellied-style witch's cauldron with three short legs. Large ones such as this could be used for cooking, rituals and spellcasting.

Brass Japanese
Used mostly as a censer for the burning of ritual incense.

Chalices and Candles

Chalices and candles are used by witches for ceremonial, ritual and spellcasting purposes. Both tools have been used in magic and sorcery since ancient times.

Chalices

Chalices are used to drink wine during rituals and as a tool to stimulate psychic ability, the subconscious and intuition. Chalices can be made of wood, stone or metal, specifically silver, gold or copper.

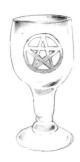

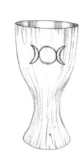

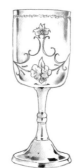

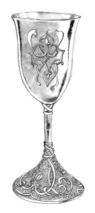

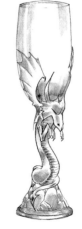

Basic
Can be used for any ceremony or ritual. Has a witch's pentacle engraved on the side.

Goddess
Best used in rituals that honour the Goddess. Has a triple moon symbol engraved on the side.

Ceremonial
An elaborately detailed metallic vessel for special ceremonial rituals.

Decorative
Finely engraved, could be used for special ceremonies and rituals or altar decoration.

Dragon
Best used by sorcerers and wizards, made of metal and glass.

Candles

Lighting and extinguishing a candle marks the opening and closing of a spell or ritual in Wicca. Depending on where the candles are placed, they can be considered to represent different things, such as the presence of the God and Goddess. Specific coloured candles are also used in spells to represent different hopes, wishes and themes.

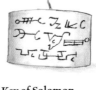

Key of Solomon
Increases mental powers, in decision making and academic studies.

Ritual pyramid
Enhances psychic powers, expands consciousness.

Votive
An offering to a deity as a plea for help.

Taper
Comes in a variety of colours. Used for rituals, ceremonies or spellcasting.

Pillar
Can be used for rituals or simply for lighting purposes.

Seven Knob or Seven Days
Used in times of difficulty. Burnt over seven days while one waits for divinatory signs.

White skull
Used in healing, purification and mourning rituals.

Black skull
For banishing negative energy, break-up rituals, exorcisms and protection spells, and for causing harm.

Altars

In witchcraft, an altar is typically a piece of furniture, such as a table or chest. A practitioner places several symbolic and functional items on the altar for the purpose of worshipping the God and Goddess, casting spells, and/or saying chants and prayers. Upon the altar typically rests a cloth, used to protect the surface. This cloth is often adorned with a pentacle.

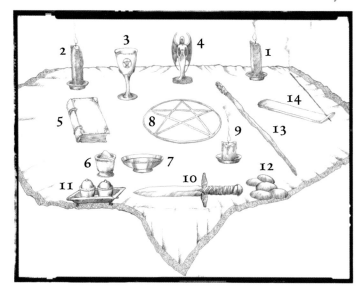

In Wicca, an altar is often considered a personal place where practitioners may put their ritual items. Some practitioners may keep various religious items upon the altar, or they may use the altar and items during their religious workings.

Draw and paint altars as the centrepiece of any scene involving rituals or spell casting. Place the altar within a large circle drawn on the ground or floor.

Not every witch sets up his or her altar in the same way. The elements and their placement vary between traditions and often between witches. If you are doing an illustration or painting of a witch who follows Wicca in particular, the set-up illustrated here is very typical. If you are doing an illustration of a witch who follows a specific tradition, research that tradition to find out how their altars are normally set up. Remember, your art has to be accurate to be believable.

The items laid out on the altar, such as bowls, cups and chalices, could be made of stone, wood or metal. Witches rarely use gold, preferring silver or pewter. These artifacts can be handmade or manufactured. Why not decorate the items in your picture with Celtic knotwork, runes, magic symbols or witch writing?

1. Illuminator candle	8. Altar cloth with a pentacle symbol
2. Illuminator candle	9. Fire candle
3. Chalice	10. Sword
4. Statue of a deity	11. Anointing oils
5. Book of Shadows	12. Cakes
6. Cup of salt	13. Wand
7. Bowl of water	14. Incense

BOOK OF SHADOWS AND GRIMOIRES

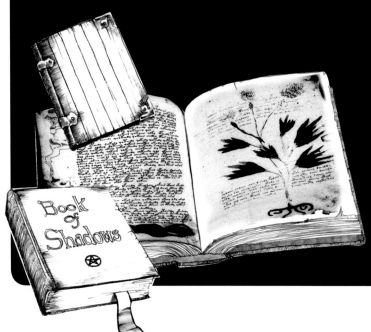

A staple of Hollywood fantasy films is the scene of a wizard's chamber filled with old, dusty books of magic. Well, there is a reality to that scene in the form of two types of books: grimoires and Books of Shadows. Grimoires date back to antiquity, whereas the Book of Shadows is a relatively modern invention used by those involved in Wicca or modern witchcraft. Any illustration or painting of a witch would be enhanced by a few grimoires or Books of Shadows in the scene. Stack them on shelves, tables or the floor. Illustrate one lying open before the witch as he or she engages in some form of conjuration or spell. Fill the visible pages with symbols (see Chapter 7) or handwritten notes.

Divination and Spellcasting Tools

Divination is the art of ascertaining information by interpretation of omens or a supernatural agent. If a distinction is to be made between divination and fortune-telling, divination has a formal or ritual and often social character, usually in a religious context, whereas fortune-telling is a more everyday practice for personal purposes. Using these tools in your artwork adds another dimension of realism, so be sure to use them in the right context, with them being used correctly.

Divination tools

Drawing a crystal ball

1. First, rough out a sketch to give a general idea of the style of your crystal ball. Above is an example of a somewhat fancy style of crystal ball with a globe sitting on a base consisting of two serpents.

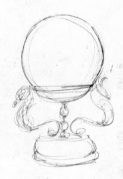

2. After deciding what the basic structure will look like, refine the sketch a bit more. Be sure to erase the unwanted lines as you go, so that you don't confuse yourself or make the drawing look too messy.

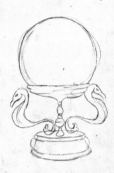

3. Continue to refine the image, giving more shape to the serpents and the base as a whole.

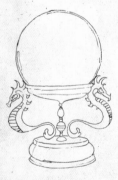

4. Add more details to the serpents and the base, and tighten up the globe, erasing unnecessary lines and marks.

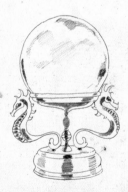

5. Add dark shading on the base to give the look of shiny metal. Also apply some shading to the crystal ball itself, but be careful not to get too heavy with it since it is meant to be made of glass (see page 29).

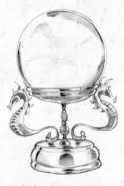

6. To finalize the image, refine the shading. Have a model of a crystal ball or any rounded glass object handy to study the way reflection and light plays on the glass. Also study the way reflection, light and shadow plays on metal.

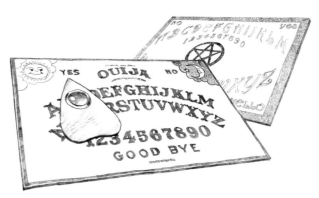

Ouija board and witch board

The ouija board consists of a rectangular board marked with letters, numbers, signs and a pointer on small wheels. With fingers on the pointer, participants ask a question. The ouija answers by directing the pointer to letters and numbers. Considered as a gateway to the other world, methods of magical self defence and watchfulness should be applied. The witch board is a variation on the ouija board.

Tarot cards

The tarot consists of a deck of 78 cards usually based on mythology or legends. When the deck is shuffled, cards are drawn and a reading guideline interpreted focusing on Major Arcana (the realm of change, the material world or the state of mind) and Minor Arcana (emotions, moral issues, finances and so on). Tarot card styles are extensive, so there is plenty of room to be creative if you want to design your own to feature in your artwork. Cards can be purchased in stores or on the Internet.

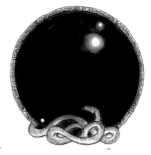

Scrying mirror

This is an ancient form of divination that is activated when the scryer concentrates on or stares at any object that has a shiny surface, until visions or impressions appear. These are then interpreted by the scryer. Scrying mirrors are normally black with either simple or elaborate frames.

Bones

Bones and skulls of animals are used in spellcasting, calling upon their spirits and their symbolism of divination for aid.

Spellcasting tools

Most of the magic work of witches and sorcerers is ritual magic, where power is gathered and directed through a rite or ceremony. Most of these rituals involve the use of a combination of elements and tools. Some of these tools are ordinary household items, whereas others are specifically created for magic use. All magic tools must be consecrated before they can be used effectively.

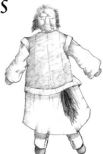

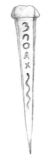

Hex doll
Based on the desires of a client, a doll is made to represent the one receiving the spell or curse. These are normally malicious, but some can be romantic.

Spell nail
The nail is inscribed with magic symbols. As an incantation is recited, it is hammered into the object designated by the spellcaster.

Witch bottle
Used to deflect witchcraft attacks, a bottle is filled with sharp objects, such as pins, nails or broken glass, sealed and buried after the maker adds their urine.

Incense
The smoke and perfume of burning incense has been used in rituals for thousands of years. It is believed that it carries one's prayers to the gods.

Amulets and Talismans

The world of magic is full of amulets and talismans, many of which date back thousands of years to ancient cultures such as the Egyptians, Babylonians, the Celts of Ireland and the Chinese mystics. They are an essential part of outfitting your magical figures. Amulets and talismans help to define the character and identify its culture, background and magical path.

Amulets

Amulets, from the Latin amuletum ('a means of defence'), are worn as protection to ward off evil, destructive or undesired forces or events. They were traditionally natural objects with an unusual shape or odd characteristic – a strangely shaped stone or a gnarled tree branch in the form of a face, for example. Ancient peoples felt that the strange shape was proof of the object's magical properties. Today's amulets, however, no longer have to be natural objects.

Pentacle

The most common adornment worn by modern witches, either as a pendant around the neck or on a ring. It is present in all forms of magical evocation, good or evil. It is usually made of silver or pewter, but it can be made from or drawn on any metal, wood or paper. It is said to stimulate the spirit world.

Scarab

Represents Ra, the Egyptian Sun God of Resurrection and Renewal. It is usually made from precious metals and adorned with gems. Spells are inscribed on its underside for protection against evil.

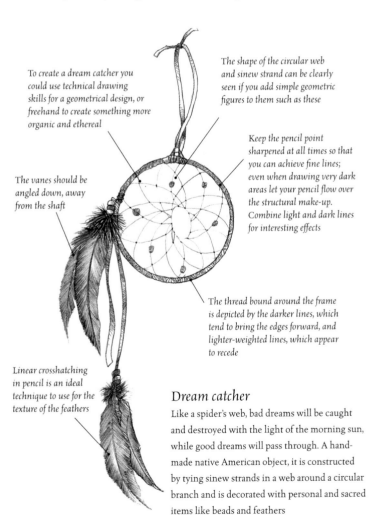

To create a dream catcher you could use technical drawing skills for a geometrical design, or freehand to create something more organic and ethereal

The shape of the circular web and sinew strand can be clearly seen if you add simple geometric figures to them such as these

Keep the pencil point sharpened at all times so that you can achieve fine lines; even when drawing very dark areas let your pencil flow over the structural make-up. Combine light and dark lines for interesting effects

The vanes should be angled down, away from the shaft

The thread bound around the frame is depicted by the darker lines, which tend to bring the edges forward, and lighter-weighted lines, which appear to recede

Linear crosshatching in pencil is an ideal technique to use for the texture of the feathers

Dream catcher

Like a spider's web, bad dreams will be caught and destroyed with the light of the morning sun, while good dreams will pass through. A hand-made native American object, it is constructed by tying sinew strands in a web around a circular branch and is decorated with personal and sacred items like beads and feathers

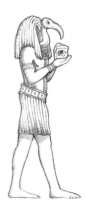

Ibis headed thoth

One of the most important deities of Egyptian magic, it controls the hearts and tongues of the gods. Master of the spiritual, physical and moral realm of the universe, it is credited as the source of all branches of knowledge, human and divine.

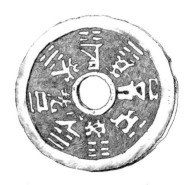

Chinese protection amulet

Worn for good fortune or to safeguard against bad spirits, it combines two potent symbols of protection: the eight trigrams of the Pa Kua (the eight phenomena suspended among us in the universe) and twelve animal signs that represent the earthly branches.

Talismans

Talismans (from the Greek telesma – 'consecration ceremony' or talein – 'to initiate into mysteries') were usually man-made objects created and consecrated in specially prescribed rituals by a witch, sorcerer or other magical person. The consecration would imbue the talisman with properties designed for a specific purpose. The object would be engraved with magic symbols, spells or the names of spirits, angels or demons.

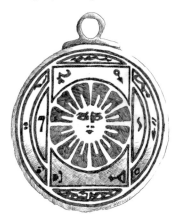

Talisman of invisibility

Spells of invisibility work by obscuring or distracting the perceptions of others so that they do not notice the magician who has enacted the magic. They cause him or her to pass unnoticed and unremembered. This example features the face of the sun surrounded by occult markings and symbols taken from the ancient grimoire, *The Key of Solomon*.

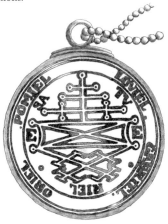

Good spirits talisman

This design bears the names of four powerful angels as well as crosses of protection from the *Arbatel Book of Transcendental Magic*. It is worn to gather the aid of good spirits, including health, prosperity, luck and protection.

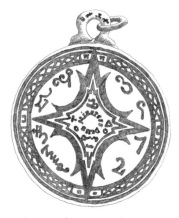

Celtic talisman for magical mystery

This talisman brings the wearer a vast increase in knowledge of every magical art. It features both alchemical and angelic symbols.

Artist's Tip

Make sure that the symbols and markings on the amulet or talisman are rendered properly and are drawn in the right place. If you don't want to use authentic ancient objects in your artwork you can invent your own. Good research is key.

FURTHER STUDY:

Ceremonial Magic, The Key of Solomon, Hermetic Order of the Golden Dawn, Natural Magic, Ephesia Grammata, Mojo, Christian Occultism

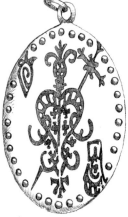
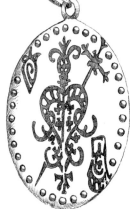

Voodoo love

Erzulie-Freda is a Voodoo Loa often associated with the Virgin Mary. She is the goddess of love, art and romance. This is her symbol, usually drawn on the floor during rituals, worn as a talisman to attract love.

Solomonic talisman to contact angels

This is used in meditation to assist in making contact with angels and other celestial entities. It is held in the right hand or placed in the centre of the forehead (third eye) and creates strong awareness and an atmosphere of relief from disturbing thoughts. The inscriptions can be the names of particular angels, using either their sigils or their names written in angelic or Enochian script.

Familiars

A familiar is a spirit who assumes the form of an animal. It is said to inspire and aid its master or mistress in witchcraft. The most common witch's familiar is traditionally the black cat, but familiars could also take the form of dogs, frogs, toads, lizards, birds, snakes, wolves or hares.

Cat

The black cat is a favourite familiar of witches. Often called a Grimalkin, they act as an intermediary for the witch, carrying out the witch's orders or as an assistant in spellcasting. The church once considered black cats to be demons in animal form.

Crow

One of the "threshold" animal familiars who wander the border between wilderness and humans. They deliver messages between the worlds, herald omens and act as spirit guides.

Snake

Long revered by Egyptian priests, the snake is associated with earth wisdom and carriers of secret knowledge. They are linked to healing, empowerment, psychic powers, rebirth and change.

Toad

Originally associated with the devil, witches used toads to cause mayhem and poison their enemies. They accompanied witches to Sabbats and their milky white secretion (Toad's Milk) was used in some forms of divination, potions, poisons and ointments.

Drawing a cat

1. Cats are lithe, graceful creatures, so you want your lines to be equally lithe and graceful. Begin with a rough sketch to work out the general pose of the cat.

2. Start adding more details and give the figure more structure. Also add the first construction lines for the tail.

3. Erase unneccessary lines as you go so that your image doesn't get cluttered up and confusing. Clean the image up so there is now a nice clean outline.

4. Build up the form with pencil shading in various directions to simulate thick fur. Add more details to the face and paws.

5. When you are satisfied with the shading, add an overall wash of deep blue. The idea is to simulate the sheen of the black fur; a common technique, especially in the world of comic books.

6. Add deeper blues and black to the coat to give your cat a more sinister look. In reality black cats can often be so black that you can't make out any details on them at all except for their eyes. The feline shown above has emerald green eyes as any demon-possessed witch's familiar should!

Chapter Three: Drawing and Painting Witches

There are many kinds of witch – almost as many as there are different cultures in the world. What we now consider the stereotypical witches of films, books and television are based on the western European model that became familiar during the Renaissance, the inquisition and the great witch persecutions between the 14th and 18th centuries.

Malefica Witch

A Malefica Witch is one who has been taught by a demon. Her actions and motivations are generally aimed at causing harm, death and destruction.

Malefica was the most common term used for witch in the 16th century. It comes from the adjective maleficus, which is Latin for evildoer. In the Vulgate Bible, the term malefici is the plural form referring to sorcerers. The *Malleus Maleficarum* or *Hammer of Witches*, published in 1487 by inquisitors Heinrich Kramer (Latinized Institoris) and James Sprenger, was used by other inquisitors and witch hunters to identify, interrogate, prosecute and execute witches. In England and New England at that time, it was believed that a Malefica Witch had made a pact with the devil, the Christian embodiment of evil. The pact would involve an exchange of a soul for special powers used to torment other mortals.

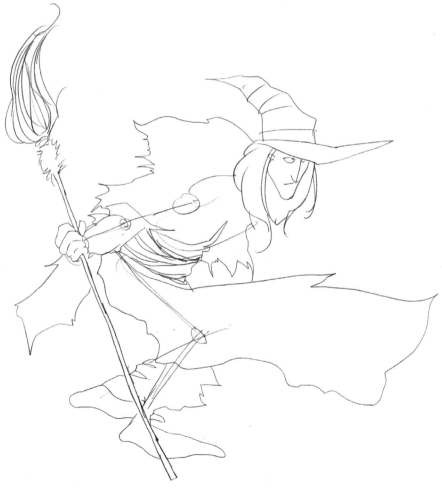

Step One

Do a rough sketch to establish the general pose for the figure and the broom in her hand. Positioning her leaning forward slightly conveys that she is aggressive and forceful.

Step Two

Refine your outline so that it is clear, making sure you erase any unwanted pencil lines as you go. You can experiment with the rendering by using tracing paper on your rough sketch, as described before, or by working on a light box.

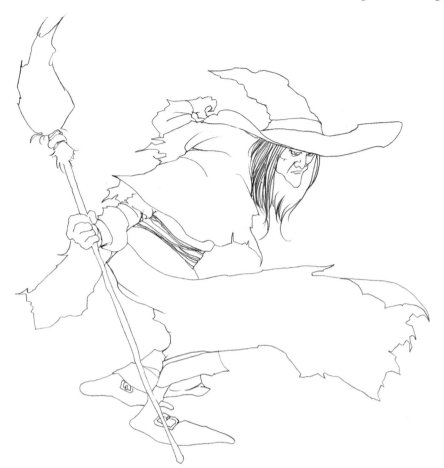

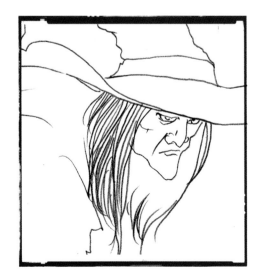

Rendering the face

Using a reference is always a good idea for constructing a believable face. For this image, a photo of an ill-tempered elderly woman would suffice. The distinctive lines around the mouth, the long chin, the thin face, the pronounced cheek bones and the scowling expression are perfect to convey such an evil character.

Step Three

Complete a full value pencil rendering
to establish all the textures, tones and
shading. Remember to decide where your
light source will be coming from before
starting the shading. This character is
facing on to the light source, as you will
see from the shadows and highlights
later on.

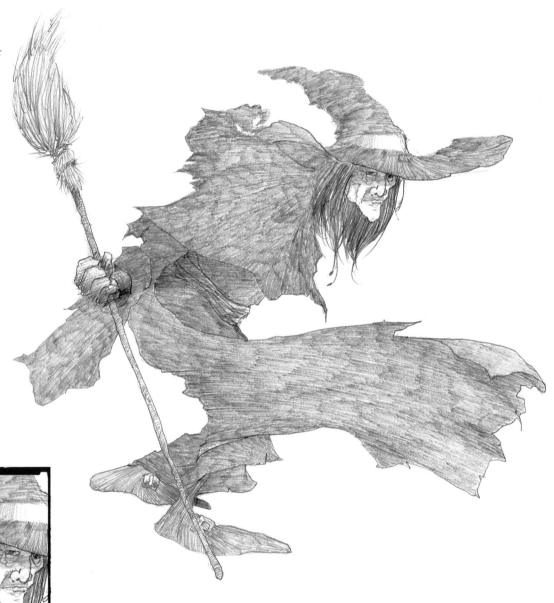

Rendering in pencil

To further enhance the figure, include shadows and textures
through shading. Make sure the wide brim of the hat casts a
shadow over the eyes, while the nose casts a shadow over the
upper lip. To add shading to the hat and cloak, apply pencil lines
that move in a direction that compliments the shapes. Give the
hair more pencil lines to add fullness to it.

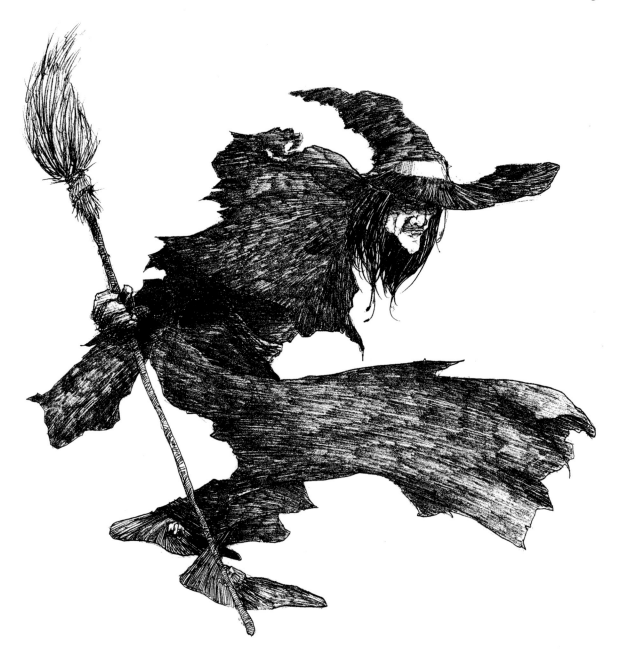

Step Four

Next, do an ink rendering over the pencil following the lines as closely as possible, giving the image a somewhat scratchy look. When the ink is completely dry, erase any remaining pencil marks so that you are left with a sharp image.

Step Five

Add an overall wash over the cloak, shoes, hat and hair using a deep, rich mixture of blue and purple. Apply a medium-toned brown wash to the skin and a grey to the whole of the broom. If you have decided not to ink your witch, you will need to use fixative on your pencil drawing.

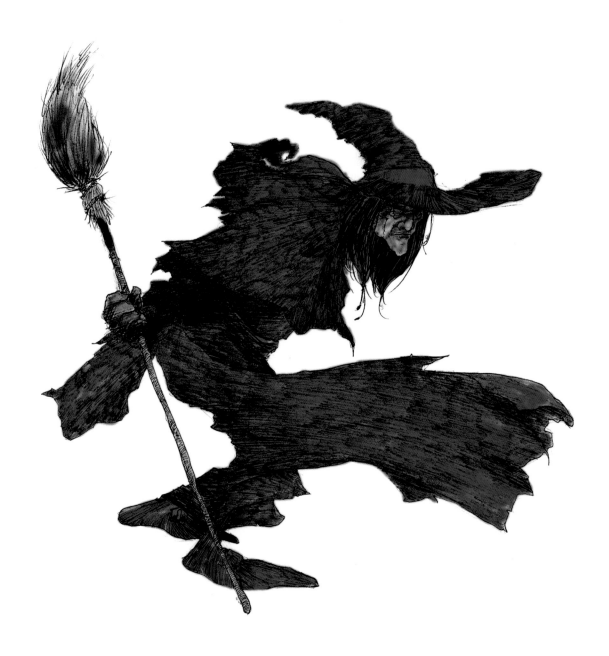

Step Six

Apply another layer of the blue and purple to add richness and depth to the image. Add a small amount of yellow and orange to the side of the figure and broom, so that it appears to be catching the light of what could be a nearby bonfire. Ensure that one of the witch's eyes glares menacingly from under the brim of her hat, and pay attention to rendering her bony hands and fingers grasping her broom. Her overall figure should appear as a dark shadowy force poised to strike with evil magic...

FURTHER STUDY:

Snow White (story), Sleeping Beauty (story), *The Malleus Maleficorum* (book), Wizard of Oz (story)

Sorcerer

The Sorcerer is one who has embraced the black arts, evil magic, and wishes to recognize and serve the devil. Sorcerers are popular characters in horror movies as they are the perfect villains, much like the Malefica Witch.

Sorcerers are beings who embrace the power that comes from occult knowledge and are not afraid to use it to obtain a desired end result. They use seduction in their magical workings and consequently place great importance on appearance and being attractive to the opposite sex.

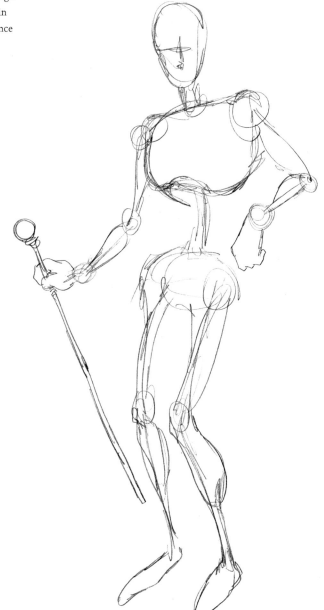

For this project, why not create a male witch? In some forms of witchcaft, a male witch is called a warlock, but most modern Wicca refers to both males and females as 'witch'. Do a rough sketch to establish the general pose.

Step Two

Building on the rough sketch, map out the shape of the figure, the cane and the cloak, erasing unwanted lines as you go.

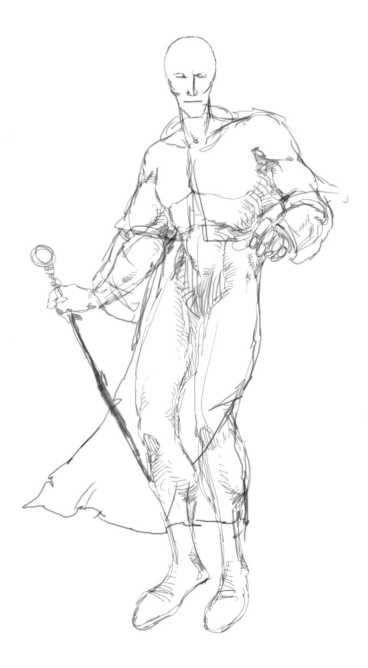

Clothing Detail

Accessorize and embellish your witch with a large upside down pentacle necklace and a skull cane, conveying his power and stature in the world of Wicca. Go with an upturned collar, a long, red coat and black trousers and shoes.

Step Three

Refine your pencil rendering, erasing all of the sketchy lines, to establish the final look. Make sure all of the details and shading are in place. Why not include the shadow of a horned figure being cast on the lower part of the cloak, as shown right? Hmmm...who could that be...?

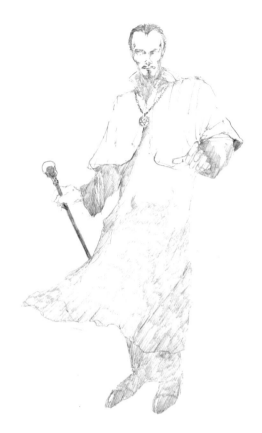

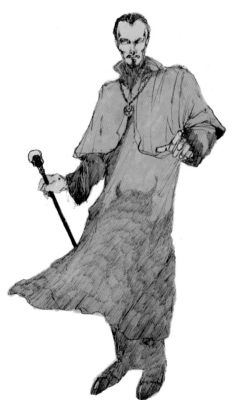

Step Four

For the first colour wash use a deep orange. Apply a slightly pinkish tone to the skin and a grey to the skull cane.

Step Five

For the final colour application, build up several layers of satanic reds to add to the richness of the image. Smooth out the skin tones with an airbrush and paint the nails black.

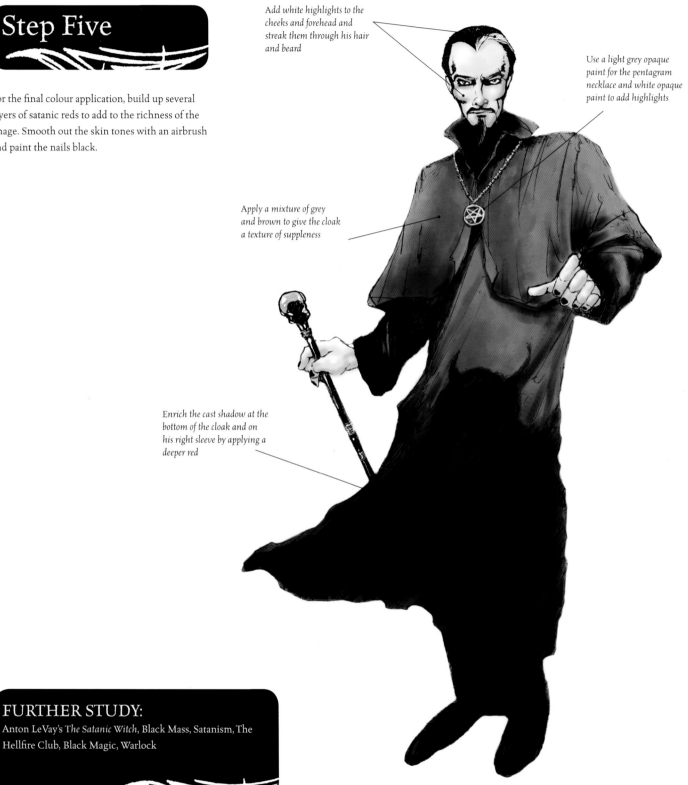

Add white highlights to the cheeks and forehead and streak them through his hair and beard

Use a light grey opaque paint for the pentagram necklace and white opaque paint to add highlights

Apply a mixture of grey and brown to give the cloak a texture of suppleness

Enrich the cast shadow at the bottom of the cloak and on his right sleeve by applying a deeper red

FURTHER STUDY:

Anton LeVay's *The Satanic Witch*, Black Mass, Satanism, The Hellfire Club, Black Magic, Warlock

Vampire Witch

The Vampire Witch combines the magical powers of a witch with the demonic blood-lust of a vampire.

In Romanian mythology, the *Strigoi* are the evil souls of the dead that rise from their tombs and transform into an animal or phantom apparition during the night to roam the countryside. A *Strigoaica* is a witch. A *Strigoi Viu* is a living Vampire Witch. Supposedly you are condemned to become a vampire if you; are born with a caul (a veil of foetal membrane still attached to the head); are born with a tail; are born out of wedlock; died an unnatural death; died before baptism; are the seventh child of the same sex in a family; are the child of a pregnant woman who didn't eat salt or was looked at by a vampire or witch, or if you are bitten by a vampire.

Step One

Do a rough sketch to set up the basic composition... why not try a hunched vampire-witch figure with several bats hovering around her?

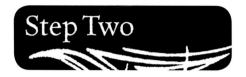

Step Two

Further refine the rough sketch to the point where you can create a clean outline drawing of the figure and the bats.

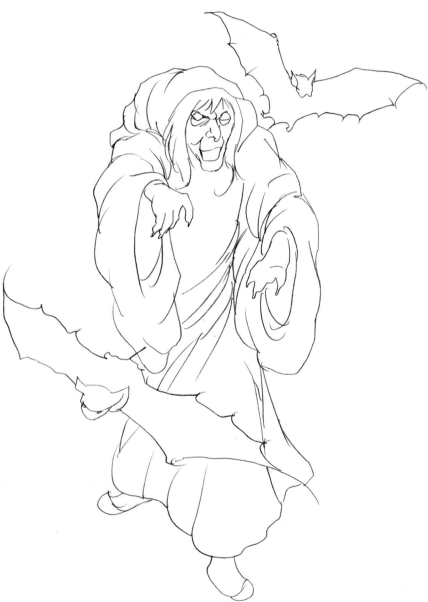

Step Three

Continue to refine the sketch, adding in details and some shading. The vampire witch should be ugly and menacing, so add any other characteristics you think are appropriately grisly and scary. You could give the witch fangs and a wild intense stare, gnarled clawed hands and a bulky hooded cloak. All of these features will combine to produce a menacing spectacle.

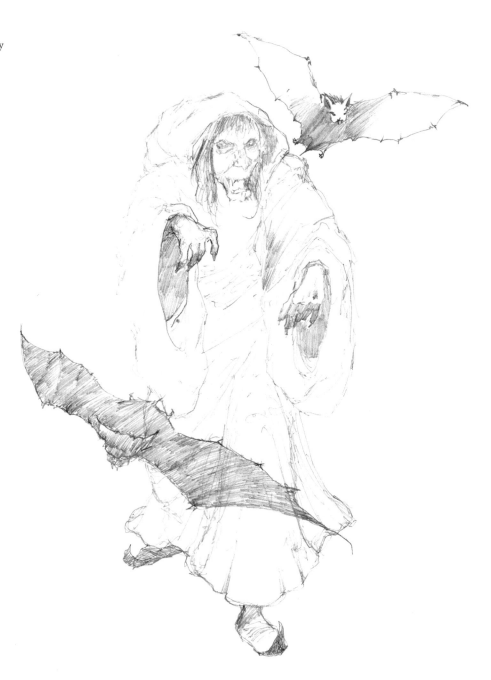

Step Four

To produce a detailed ink rendering, simply mimic the pencil rendering, but add in stronger contrasts to the image as a whole. This will make the added colours look far more intense.

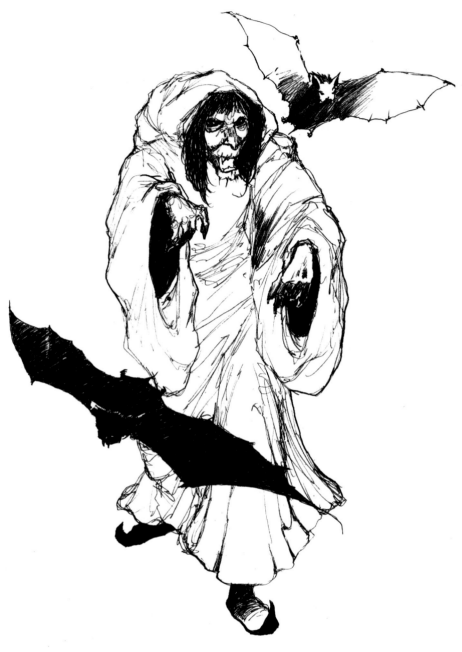

Clothing Detail

Keep the clothing simple on this figure, giving her a bulky, hooded shroud with lots of wrinkles to enhance the feeling of age and decrepitude. The hood and sleeves should almost consume the figure with only her gnarled, grisly, clawed hands and distorted face poking out of the dark recesses.

Step Five

Begin to add the colours, first applying an underlying orange and yellow wash with browns and greens added over the top.

Make this bat dark, but with some brown and green highlighting on the underside of the wings to show where the light hits the membrane. This helps to create a three dimensional effect

Use a mixture of blue, violet and pink to colour her skin to create a ghoulish, death-like palour and skin tone

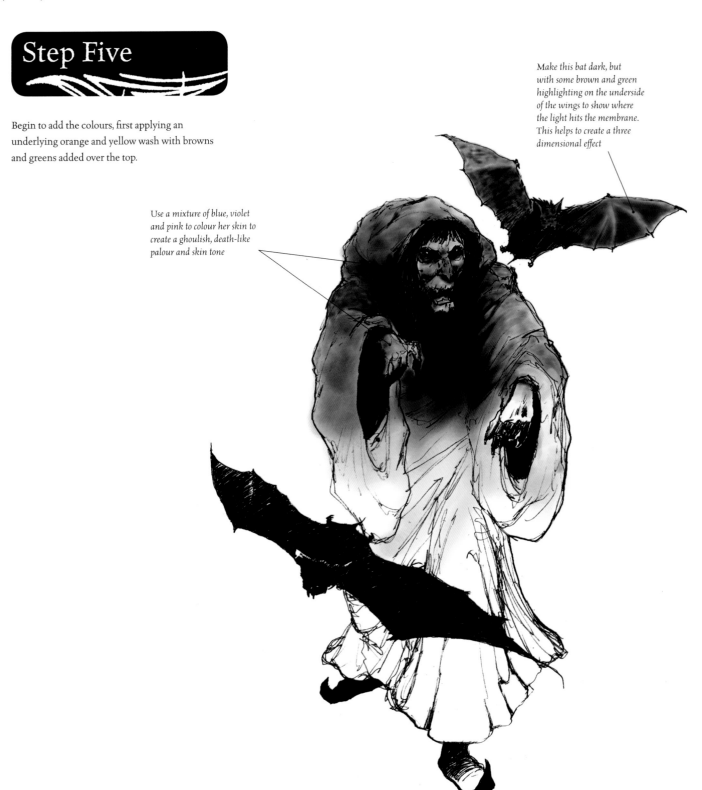

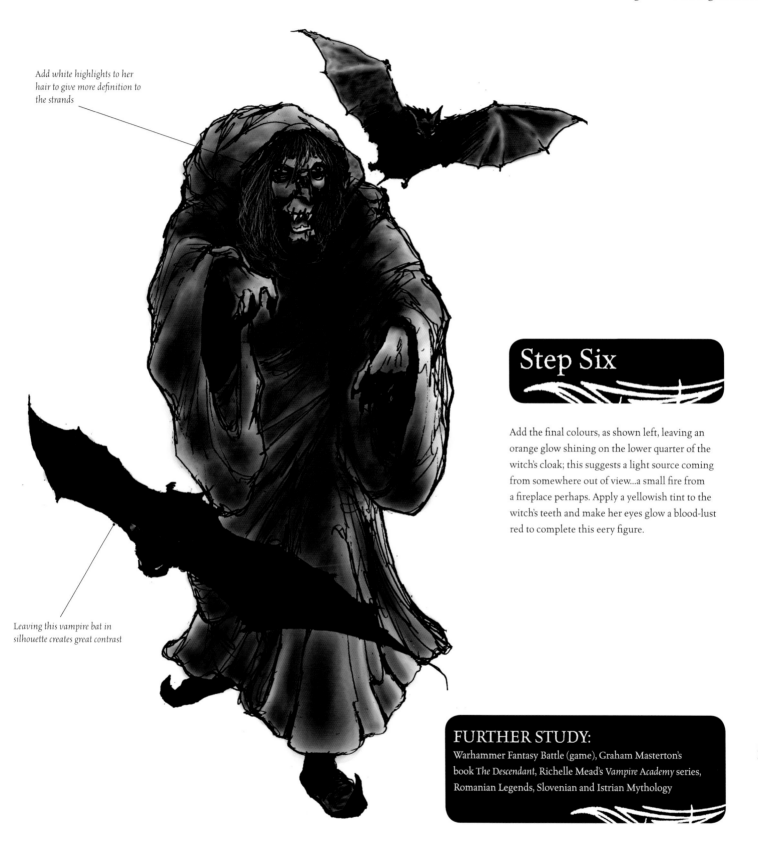

Add white highlights to her hair to give more definition to the strands

Leaving this vampire bat in silhouette creates great contrast

Step Six

Add the final colours, as shown left, leaving an orange glow shining on the lower quarter of the witch's cloak; this suggests a light source coming from somewhere out of view...a small fire from a fireplace perhaps. Apply a yellowish tint to the witch's teeth and make her eyes glow a blood-lust red to complete this eery figure.

FURTHER STUDY:
Warhammer Fantasy Battle (game), Graham Masterton's book *The Descendant*, Richelle Mead's *Vampire Academy* series, Romanian Legends, Slovenian and Istrian Mythology

Faerie Witch

Part human and part faerie, this witch has the general appearance of the former with all the magic powers of the latter.

A nature spirit, dwelling mainly in the dense forests and woodlands, Faerie Witches are either members of a family of faeries or totally solitary beings with their own agendas and motives. They have the power of flight without the aid of a broom, can shape-shift into various forest creatures, can walk on water, can appear as mist or disappear entirely as quickly as the wind. Like faeries, their temperament is quick to change from benevolent to dangerous if they are displeased. Faerie Witches can be human sized if they wish, but can also be smaller than a blade of grass.

Do a rough sketch mapping out the general shape of the Faerie Witch perched atop part of a gnarled and stunted tree trunk. Her gossamer clothing should be flowing down and away from her. You could sketch some glass witch balls hanging from the branches.

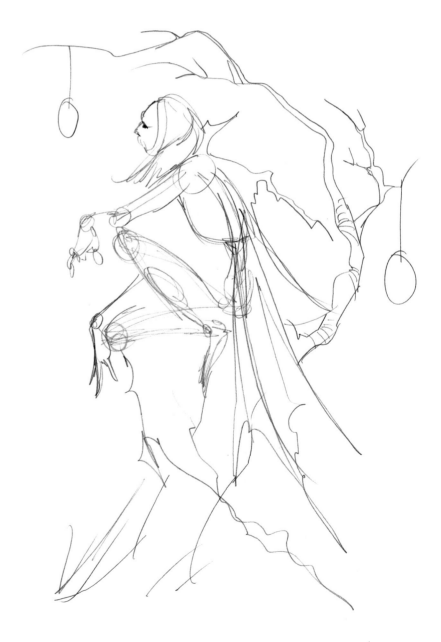

Step Two

Create a more refined rendering adding most of the final details, including texture on the tree trunk, the witch's hair and the flowing ribbons of clothing.

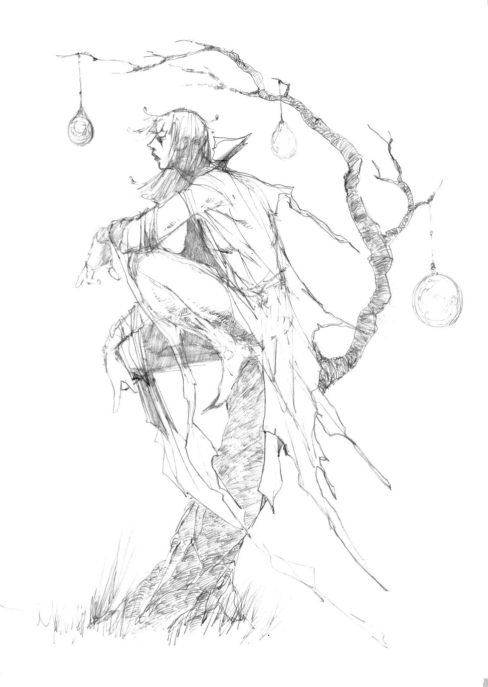

Detail

Give the figure, hair and clothing a whimsical touch to make her look light and delicate. The shape and flow of her hair and clothing should reflect the plant life that surrounds her, highlighting her status as a creature of the forest.

Step Three

Finalize the outline of the witch, the balls and the tree.

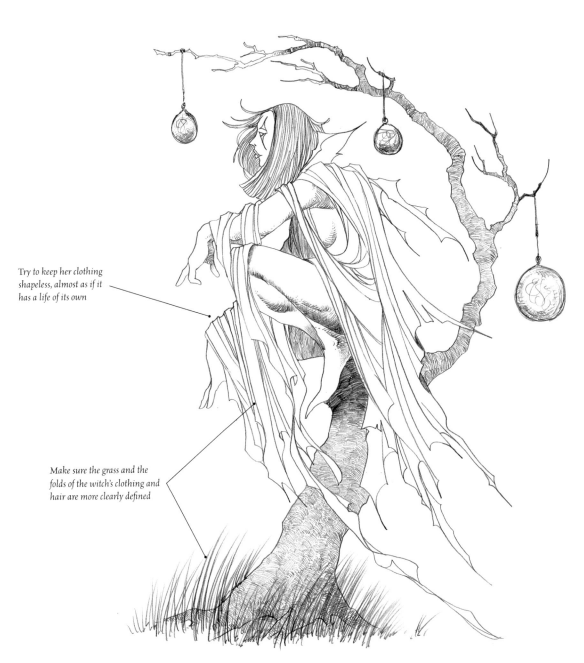

Try to keep her clothing shapeless, almost as if it has a life of its own

Make sure the grass and the folds of the witch's clothing and hair are more clearly defined

Step Four

Next, apply a colour wash using a pale green, a brown and a hint of burnt orange.

Add a small amount of bold colour to the witch balls

The more gnarled and interesting the form of the tree, the more striking the composition

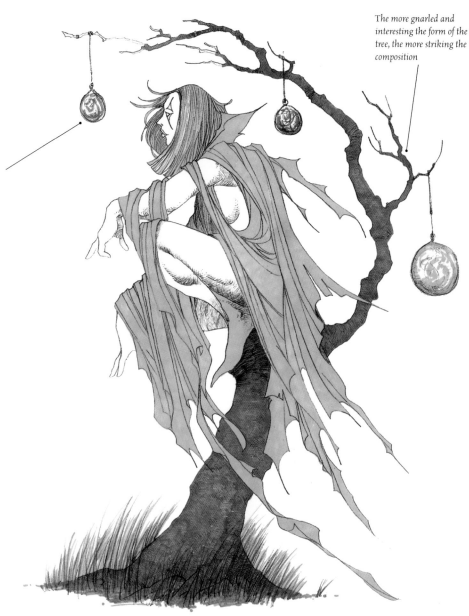

Composition

Place the figure so that she is perched on a tree stump to convey a sense that she is spry and airy, able to defy gravity with her enchantment. Dress her in the greens of the forest in a thin wrap that barely covers her pale, nearly translucent, skin. Hang small colourful witch balls from the branches around her to snare evil magic, protecting her from dark spirits.

Step Five

Use a thin brush with a bit of dark green to create what looks like a pattern of symbols on the clothing. Apply darker shades of the mid-tone colours to create dimension through shading.

Add colour and highlights using paler colours to the glass witch balls to make them look like they have filaments inside in various twisting shapes

Make the skin pearly white and use a pale blue for shading

Add darker greens to the clothing to give the folds more definition and add shading to the underside

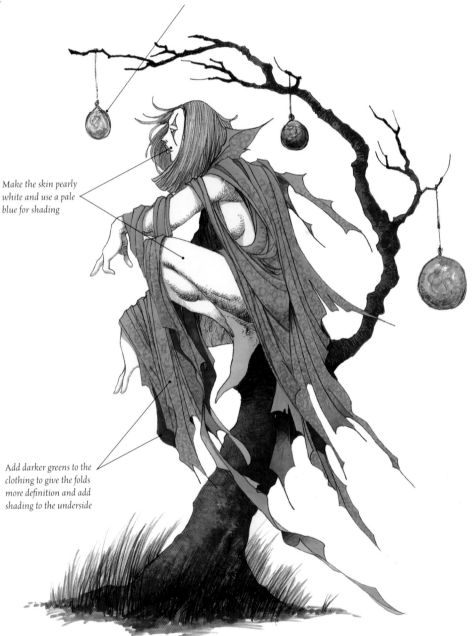

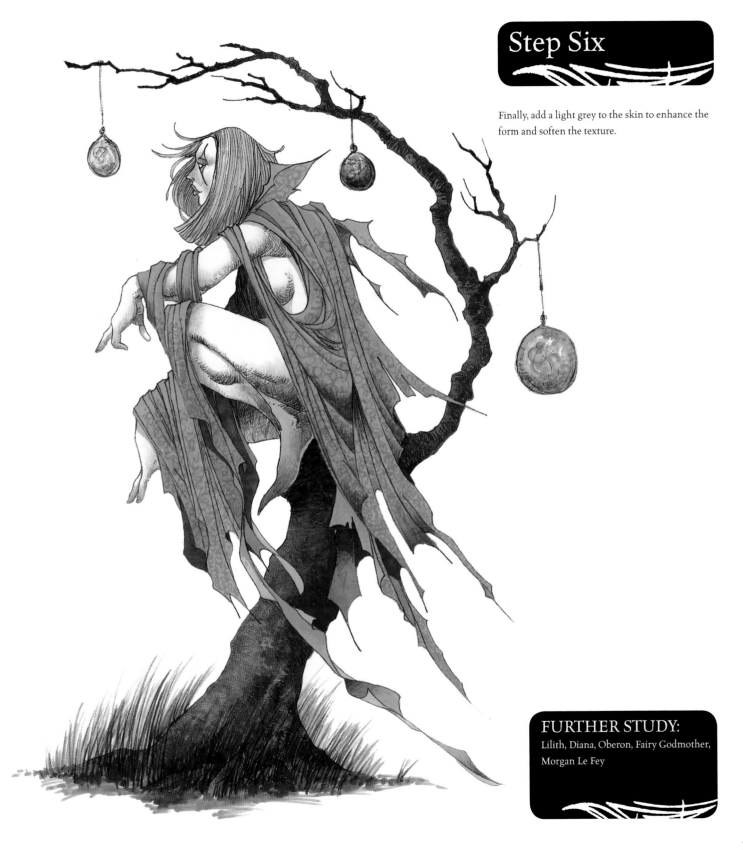

Step Six

Finally, add a light grey to the skin to enhance the form and soften the texture.

FURTHER STUDY:
Lilith, Diana, Oberon, Fairy Godmother, Morgan Le Fey

Lycian Witch

Lycian witches traditionally leave their bodies at night so that those of the Wolf Clans will find each other between the worlds, regardless of the time or place.

The Wolf Clans of western Europe were quite widespread in their reach. They extended from the far northern Scandinavian countries down into Ireland and England, France, Spain and Italy. Inquisition records still exist of the questioning done by the Catholic church of these 'Wolf Witches'. Any child born with the caul was considered to have been preordained to become one of the wolves. The records seem to point out that these witches believed that they left their bodies at night to become wolves, and then met others who did the same and would roam in packs. They were known as the 'Benandanti' in Italy.

Do a a light, rough sketch mapping out the basic composition, using circles to help you decide on and render the joints. Illustrated here is a wolf running with the spirit of the Lycian Witch emanating and hovering above it. Use a thin lead pencil in the H range for light sketching.

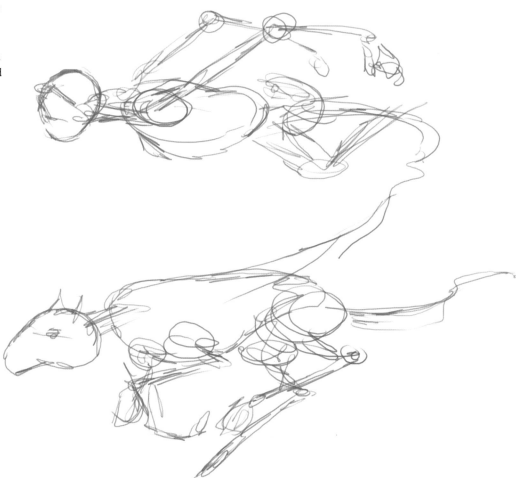

Step Two

Refine the rough sketch adding a few more details to the human figure and the form of the wolf. It is a good idea to collect some reference materials on wolves to use as inspiration.

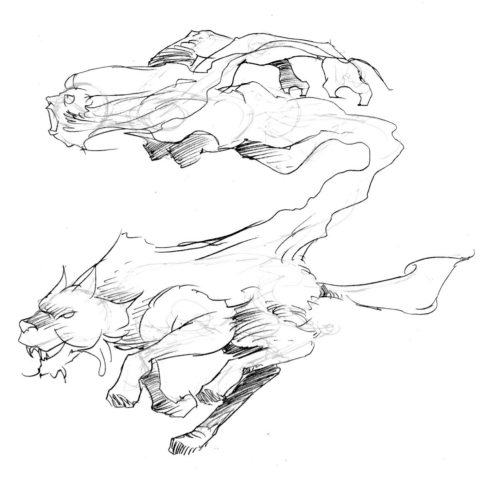

Capturing Movement

The individual parts of the body are connected by joints. Each of these joints varies considerably in the type of motion it allows. There are hinge joints such as elbows and knees, ball and socket joints such as hips and shoulders, and flexible column joints such as the spine and neck. When a figure is walking or running, the body shifts its weight alternately from one leg to the other and the centre of gravity passes through the foot to the ground. When running, the figure leans in the direction of the movement ahead of the centre of gravity. Study animals and people in motion to get a sense of how best to draw them in action.

Step Three

Further refine the outline of the figures, erasing the rough sketch lines as you go. It is important that the wolf looks like it is moving fast, so make sure you include lots of action lines and agressive, forward-going movement.

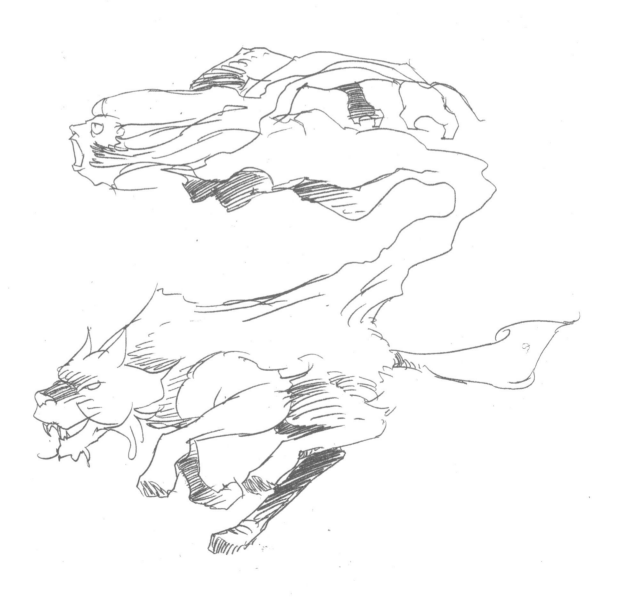

Step Four

Begin to fill in the fur of the wolf, the flowing hair of the witch, the details on both of their faces and the basic shading. See page 29 for advice on rendering the fur.

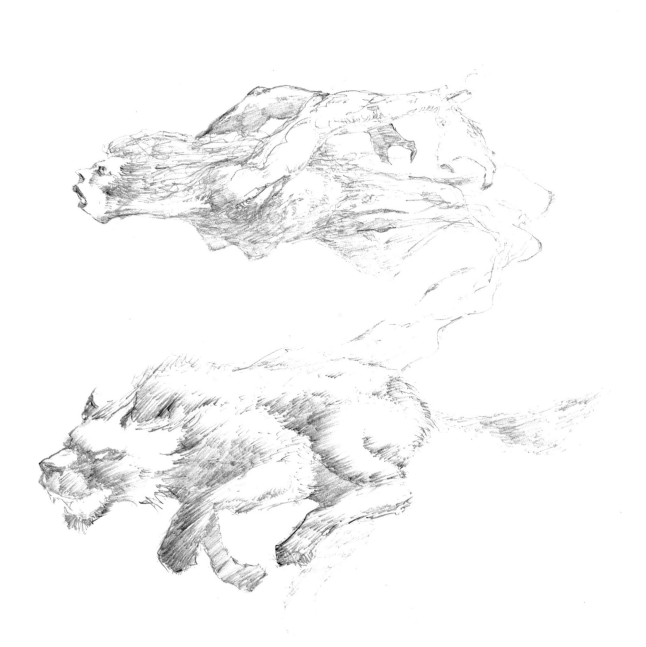

Step Five

Enhance the pencil sketch by going over it again with a darker pencil, such as a very sharp 4B. Make sure you keep it sharp or your lines will be too thick.

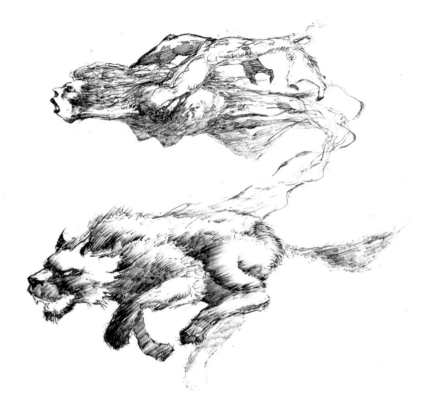

Step Six

Apply an initial colour wash of a pale blue mixed with a hint of violet to establish the middle tone of the illustration. This colour mix also lends a cold atmosphere to the picture.

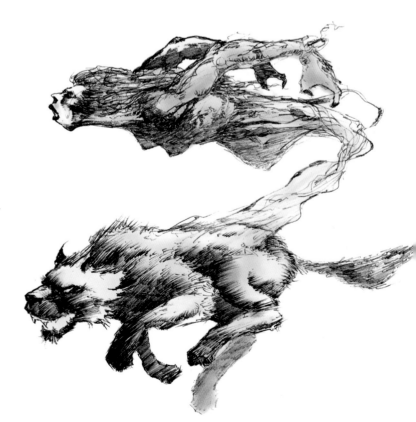

Step Seven

Sticking to cool colours such as blues and greys, further enhance the colours to make them richer. Since the Wolf Clans run at night, keeping the colours cool increases the feeling of a crisp, full moon night filled with these ghostly wolf-witches on the hunt. Add the white highlights to create a misty sheen to their bodies. You can accomplish a soft, airbrush-like effect with lightly applied white chalk or pastel.

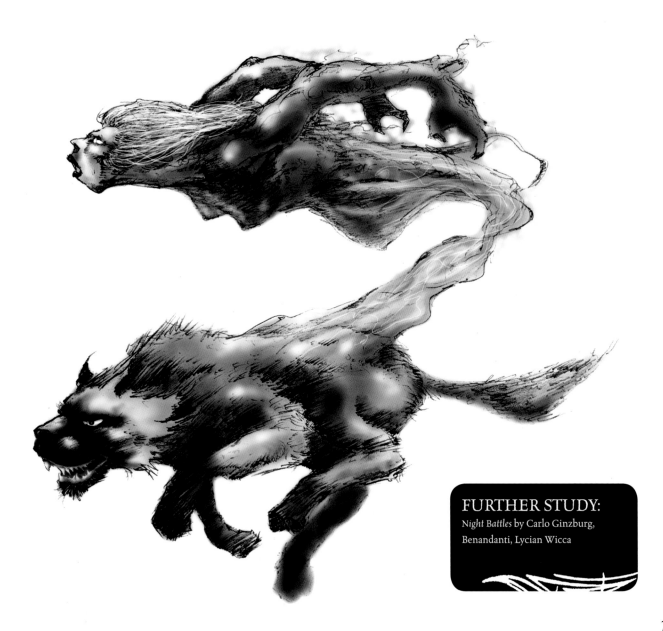

FURTHER STUDY:
Night Battles by Carlo Ginzburg, Benandanti, Lycian Wicca

Spider Witch

This is a dark, powerful and dangerous magical witch that one should seek to avoid. More demon than human, she can shape-shift into a large, frightening spider when attacked, or into a very small one to make her escape.

The Spider Witch is mostly a character of modern day fantasy tales and role-playing games. She is conveyed as a power-hungry creature that is half human, half spider, who casts evil and cunning spells and has elemental powers. She can weave intricate and powerful webs to ensnare people, pierce them with her poisonous sting or bite them and drain their blood, much like a vampire. She can also control other insects to make them do her bidding, although the black widow spider is her preferred familiar.

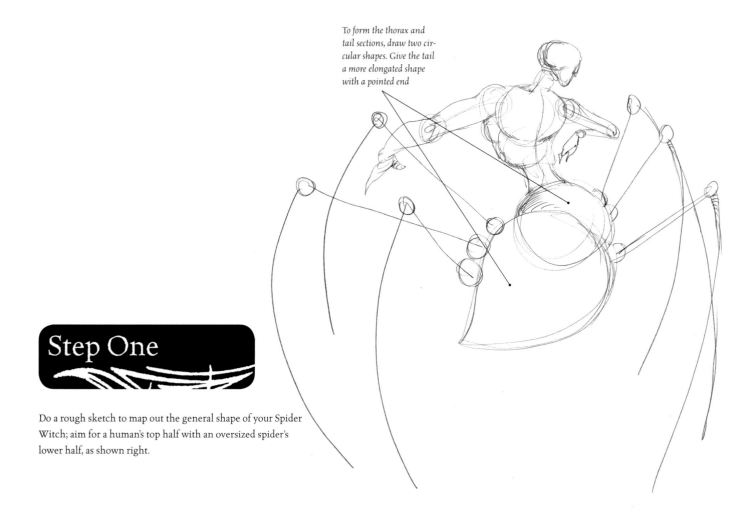

To form the thorax and tail sections, draw two circular shapes. Give the tail a more elongated shape with a pointed end

Step One

Do a rough sketch to map out the general shape of your Spider Witch; aim for a human's top half with an oversized spider's lower half, as shown right.

Step Two

Create a more refined rendering, adding more substance to your Spider Witch with shading and texture. You could also add a large, black, jagged tattoo to your witch's back, as shown right.

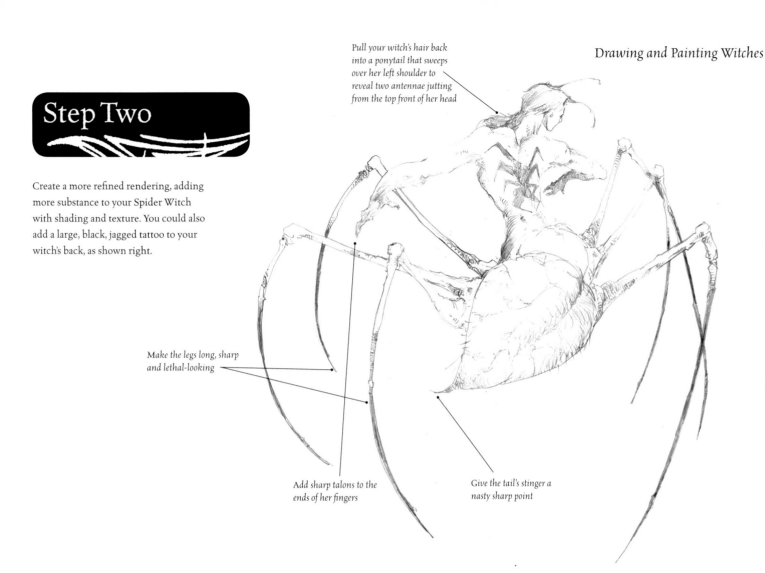

Pull your witch's hair back into a ponytail that sweeps over her left shoulder to reveal two antennae jutting from the top front of her head

Make the legs long, sharp and lethal-looking

Add sharp talons to the ends of her fingers

Give the tail's stinger a nasty sharp point

Rendering Spider Markings

The best idea is to find a book on spiders or look them up on the internet. The type of spider you choose to use as a reference is basically up to you. Find one that has distinctive markings that you can either use as it is or manipulate into something else, depending on how creative you want to be when developing your Spider Witch. Choose an aggressive-looking and unusual spider for the most interesting form.

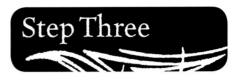

Step Three

Ink in the outline of your Spider Witch, so that it is ready to add colour. The inked version creates the solid black and solid whites of the picture. Erase any remaining pencil lines so that your drawing is clean and sharp.

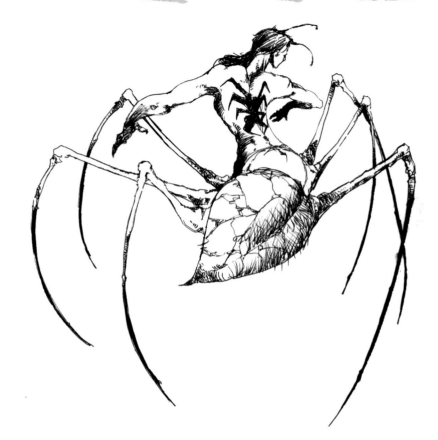

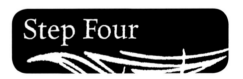

Step Four

Next, apply a colour wash. In the example shown right, the entire figure has been given a deep yellow-orange overall wash, which is the middle tone. You can colour the spider any shade you choose, but ensure that your initial colour wash is a mid-tone of the final colour to maximize the depth and three dimensional look of the finished piece.

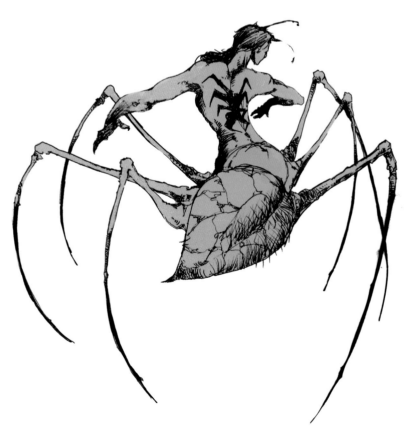

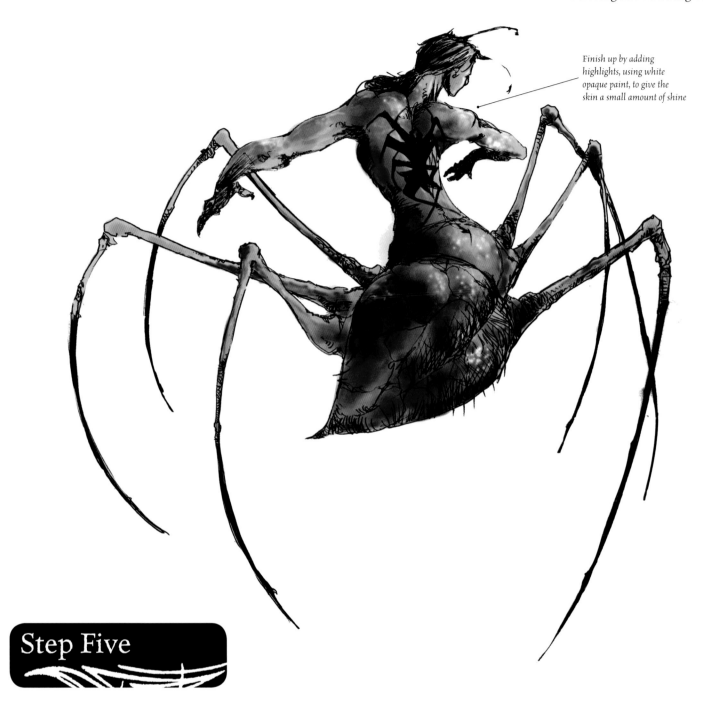

Finish up by adding highlights, using white opaque paint, to give the skin a small amount of shine

Step Five

From there, build the tones up in both directions: mid-tone up to white and mid-tone down to black. Apply a mixture of sepia, burnt-orange, green and grey to give your Spider Witch an earthy yet demonic look. Remember to decide on your light source direction early on in the process, and use this to work out where to apply the highlights.

FURTHER STUDY:
The Avalon Collection (book series), Makdee (film), Arachne (game character), Zenthora (from the book *Glim the Glorious*)

Celtic Druidess

Since witches have, for the most part, come out of the 'broom closet', there have been a number of new traditions formed from the old. The Celtic belief system is one of the more popular foundations for modern witchcraft including, most notably, Wicca and Druidry.

Celtic witchcraft has its origins in Ireland, Scotland and Wales. The Druids were the religious leaders of the Celtic people. In ancient Celtic society the Druids and Druidesses composed an intellectual elite, whose knowledge and training placed them as magical priests and priestesses of the Celtic religion. The Druids mediated for the people, performed sacrifices, interpreted omens and presided over religious ceremonies. They believed that the soul did not die with the body, but passed on to another. Celtic legends are filled with female rulers, often said to have mystical powers equal to that of the male rulers. With the spread of Christianity, the Church labelled female Druids as witches in order to make their power seem evil. The Christians feared the Druids and Druidesses not only because they were a source of great religious power and the centre of knowledge for their people, but also because many of them preached strongly against conversion to Christianity.

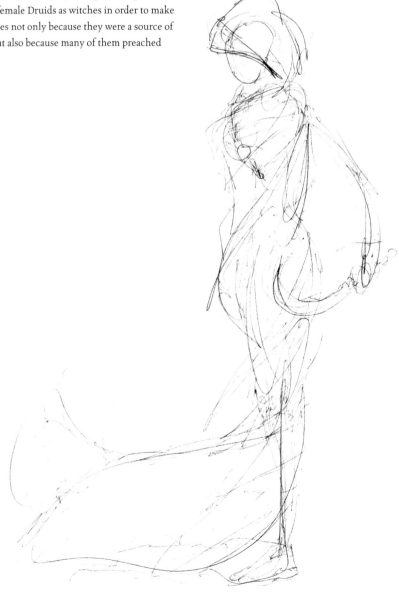

Step One

Do a rough sketch to establish the general pose for the figure. You could also indicate where a weapon will be held in the left hand, if you want to include one. Make sure that you include the sweeping outline of what will either be a flowing robe or a long gown.

Step Two

Draw the outline of a long staff, to be held in the right hand. Include a sweeping curve near the face where the hair will flow down and the slight hint of a chorded belt, which will be blowing in the wind. This stage in the drawing should refine the details further and use more positive, finished lines.

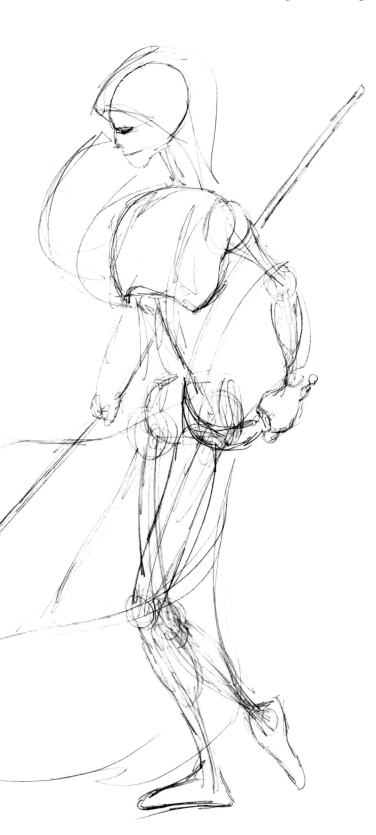

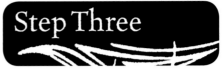

Step Three

At this point, establish a solid outline and remove all of the sketch lines. You can use tracing paper on a light box to help with this.

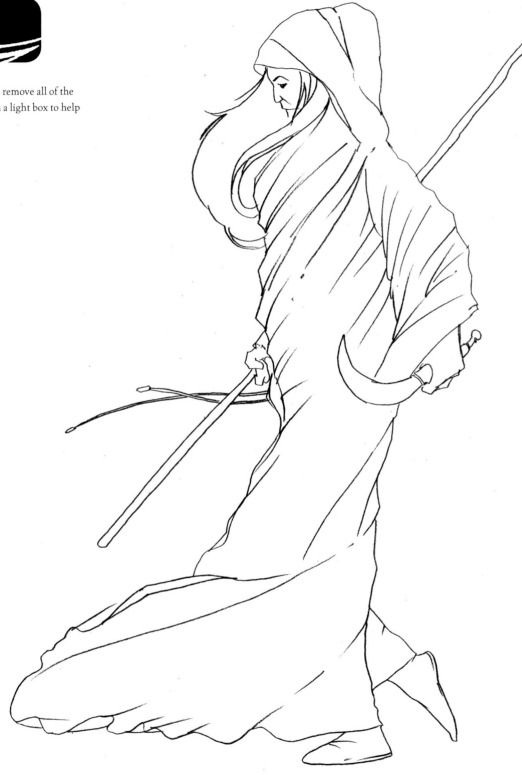

Step Four

Begin to fill in the details of the hair (see page 29), folds in the garments and the textures on the staff, the knife and the shoes.

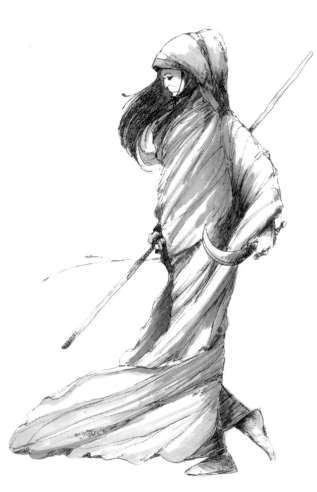

Step Five

Establish the middle tone with a colour wash of grey. The grey is placed to create shading and shadow.

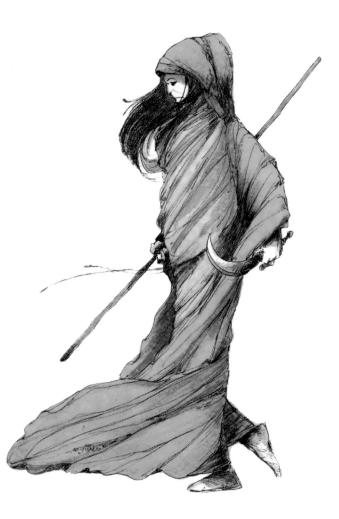

Step Six

Next, apply a colour wash of pale green and pale blue over everything except the skin, the staff and the knife handle.

Step Seven

Finish up this image by adding of an extra layer of blue, green and a hint of violet to the clothing.

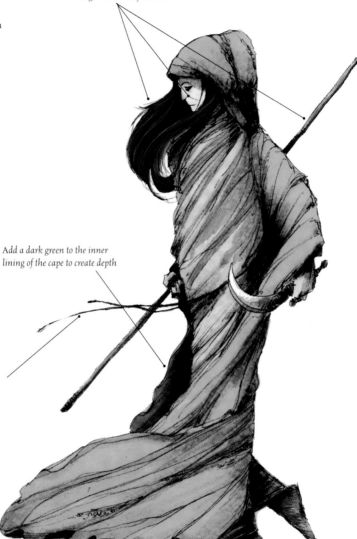

Apply pink, Indian red and light brown to the skin tones and a reddish-brown to the hair, the staff and the knife handle

Add a dark green to the inner lining of the cape to create depth

Make the cord a solid black, and make sure it is at such an angle that it accentuates the sense of movement and flow of the character in its windswept environment

FURTHER STUDY:

Laurie Cabot, Faerie Magic, The Horned God, Witta, St. Bridget, Stonehenge, The Larzac Stone, Folklore and Legends of Ireland, Scotland and Wales

Goth Witch

One of the newest variations of modern witchcraft is the Goth Witch. This is a form of witchcraft that combines the basic traditions of Wicca with the subculture of Goth. Dark witchcraft, Goth witchcraft, Nocturnal witchcraft and Dark Wicca are a few of the major paths that incorporate the Goth culture.

Goth began in the underground Punk music scene and evolved into a movement that grew in popularity amongst the young looking for a way to embrace the darker side of thought, music and art. The songs of Bauhaus, Peter Murphy, Switchblade Symphony, Dead Can Dance and Type O Negative are just a tiny sampling of the ever-expanding Goth music scene. This type of thought naturally led to an interest in the occult and thus witchcraft was embraced, but with a slightly darker twist. Goths generally prefer to wear black clothing, silver jewellery consisting of various Pagan symbols and even crosses, piercings, pale corpse-like make-up and dyed black hair.

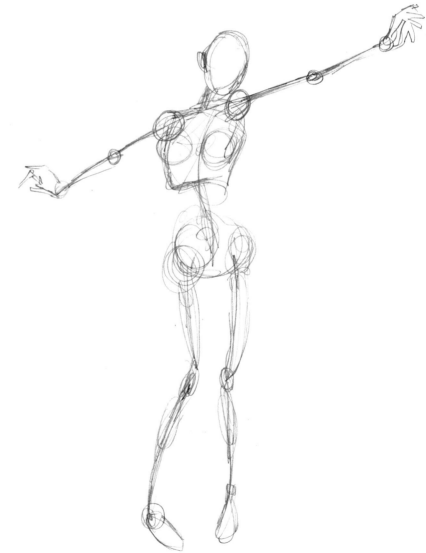

Create a thumbnail sketch that forms the basic skeleton upon which you can build the figure. You can put your witch in any pose you wish, but just make sure it's plausible.

Step Two

Follow this up with a rough sketch, bulking out your figure a little more. Now you can see the shape of the figure forming, why not add an outline for a wild hair style and big, chunky boots, as shown right? Try not to add too much detail to these embellishments at this stage.

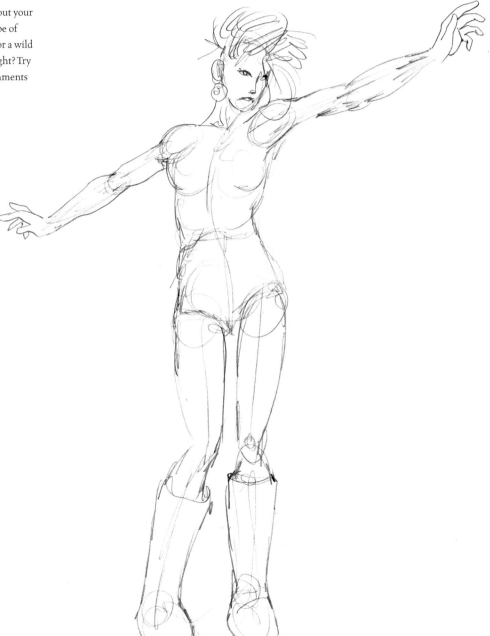

Step Three

Working on tracing paper or a light box, do a refined pencil sketch, adding more details to the clothing, face, hair and hands... not to mention those chunky boots. These boots are your chance to really work your shading and highlighting to best effect.

Step Four

Now get down to the details. With a nicely sharpened 2H pencil, add a variety of textures to the clothing, from the mesh of her leggings and sleeves to the leather-like wrinkles of her fingerless gloves, tattered skirt and turtleneck top.

Make sure that her face is more refined and the strands of her wild hair are made fuller

Use a variety of hatching and crosshatching (see pages 18-19) to create really strong textures in the clothing

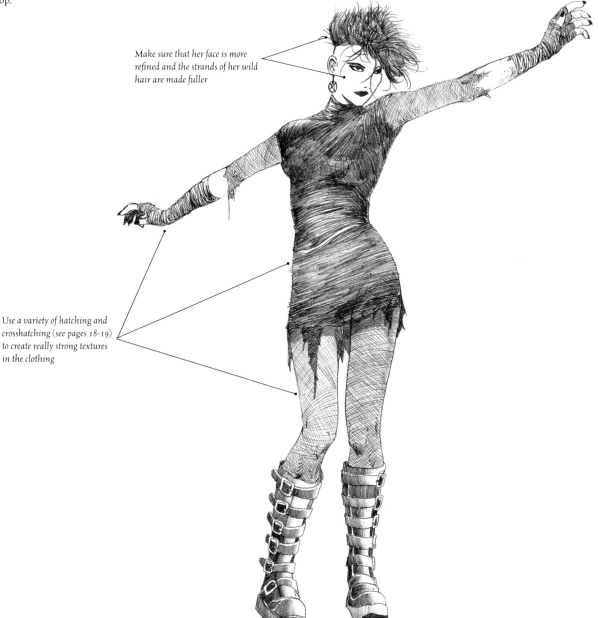

Step Five

Next, apply an overall colour wash of a medium blue with a hint of purple for the mid-tone, or experiment with any other mid-tones you choose. Trying different colours out for yourself is the best way to learn tonal values and what really works for you.

Step Six

Finally, add more blues to build up the shading and further define the form. You can also use opaque white to add the gleam to her chain belts, necklaces, earring and hair.

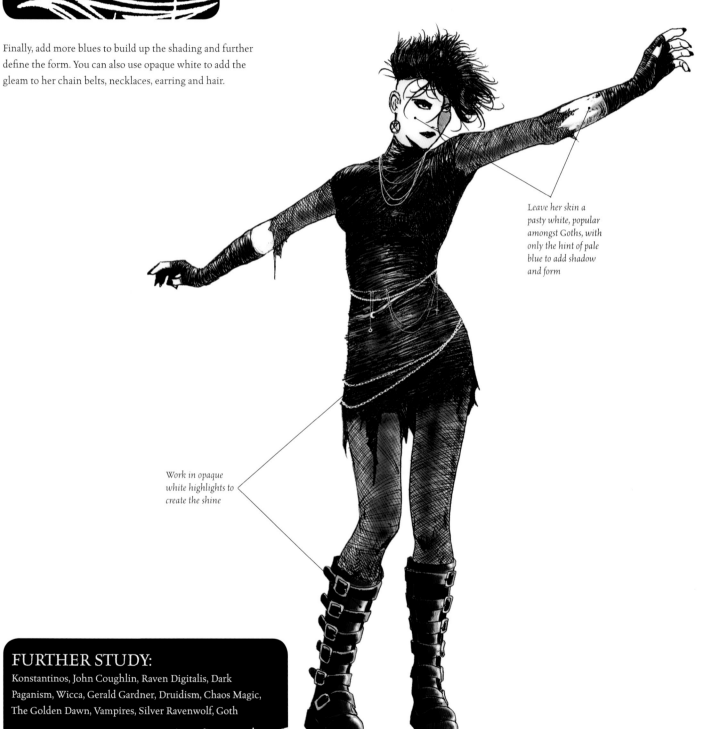

Leave her skin a pasty white, popular amongst Goths, with only the hint of pale blue to add shadow and form

Work in opaque white highlights to create the shine

FURTHER STUDY:

Konstantinos, John Coughlin, Raven Digitalis, Dark Paganism, Wicca, Gerald Gardner, Druidism, Chaos Magic, The Golden Dawn, Vampires, Silver Ravenwolf, Goth

Voodoo Priestess

During the 19th century Voodoo Priestesses became central figures to Voodoo in the United States. They presided over ceremonial meetings and ritual dances. They also earned an income by selling charms, amulets and magical powders guaranteed to cure ailments, grant desires, and confound or destroy one's enemies.

Also known as Houdou, Voudoun and Hoodoo, the practises of the Haitian born religion of Voodoo are found in New Orleans, New York, Houston, South Carolina and parts of western Africa. Magic is an integral part of Voodoo; it can be used for both good and evil purposes. The roots of Voodoo can be traced back to Africa, where it began its journey to America through the slave trade. Despite the efforts of slave owners in South America to convert the slaves to Christianity, Voodoo flourished, but in secret. Slaves would go through the motions of Catholicism during the day and engage in their Voodoo practices at night. The real power of Voodoo resides in the secret societies. Membership requires total devotion, blood oaths and pain of death for betraying society secrets. The gods (Loas) of Voodoo are many and over time they have become blended with the Catholic saints, a phenomenon known as syncretism.

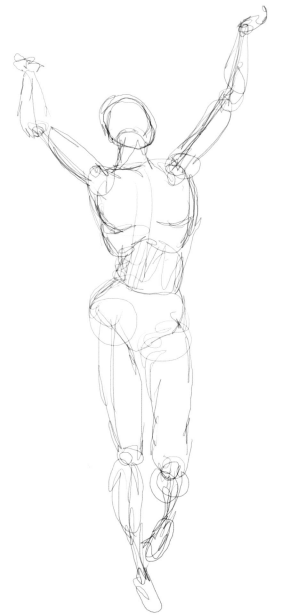

Step One

Begin with a rough sketch to work out the general pose of the figure. Why not sketch your Voodoo Priestess holding up a large boa constrictor snake? To do this, place the arms in a position reaching above the head, as shown right.

Step Two

Using a light box or tracing paper, create a clean pencil sketch outline of the body, including details of the face, fingers, toes, etc. References for the human body are particularly useful for these types of poses.

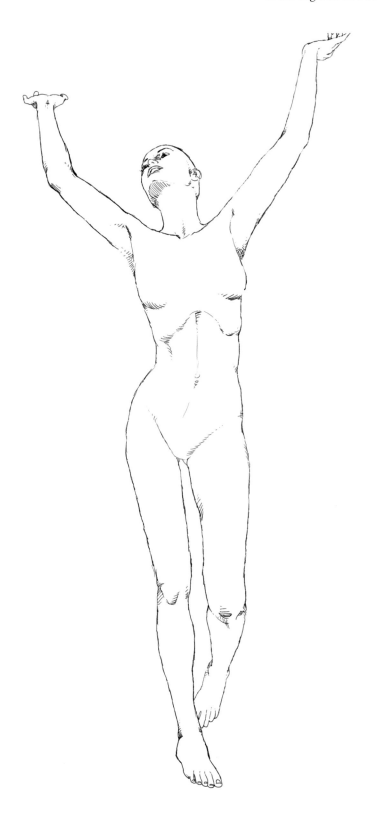

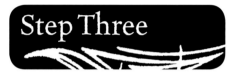

Step Three

Next, begin to create outlines for the priestess' clothing and the snake that she will be holding over her head. It's a good idea to use reference material for this step. The clothing worn by Voodoo practitioners is not entirely specific, but the clothing worn by people in the Carribbean should be represented accurately. You should also get a good reference book on snakes, so you can render the boa constrictor correctly.

Make the clothing look as though it is made of very light, loose-fitting material that flows around the body to suggest movement

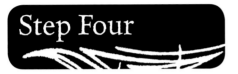

Step Four

Place the refined pencil sketch on a light box (or use tracing paper) with a sheet of vellum over it to render the ink outline. This will be the final outline to which you can apply the colours.

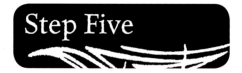

Step Five

Apply a colour wash using a medium shade of grey for the priestess' skirt and top, a light violet for her sash, a medium-brown for her skin, a rusty red for her headscarf and a muted yellow for her shawl and the snake.

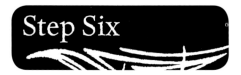

Step Six

Add ink details to create patterns on the hem of the shawl and on the snake. Further enhance all of the colours and shading. You could include a dark shadow over her lower half, as shown right, to suggest that something is standing in front of her out of the scene, perhaps a demon that she has summoned!

FURTHER STUDY:
Gris Gris, Marie Laveau, Santeria, Macumba, Zombie

Add white highlights to the snake to make its skin appear slick and glistening

Add shading under her arms to give depth to the shawl's underside

Use further shading to give form and texture to the clothing, making it appear soft

Chapter Four:
Drawing and Painting
Dark Worlds

The background settings for your witches, warlocks and other magical beings are essential for creating a convincing drawing or painting. The dark worlds they occupy are many and varied, but here are a few of the basics...

Wizard's Chamber

The powerful wizard sometimes lived in the castle of the King if he served as a counsel or royal mage. Otherwise, he would have his own dark castle on the far side of the kingdom, in some remote difficult-to-reach area protected by dense woods and inhabited by strange creatures, or perhaps atop a formidable craggy mountain peak. Inside would be his many rooms filled with ancient books of magic or grimoires and various tools of his craft.

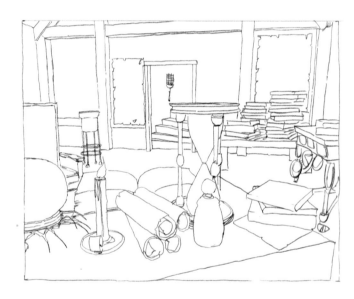

Create a pencil sketch laying out the wizard's chamber, including appropriate objects such as stacks of books, an hour glass, candle, a crystal ball, etc (see 'Tools of the Trade', pages 36–51). As in all compositional sketches, several attempts may be required to get things arranged in a pleasing way. In this image, the objects should occupy the lower half of the picture while the upper half should be fairly vacant, giving the picture a heavy bottom to rest on.

Outline the elements more heavily to refine them and define their shapes more solidly.

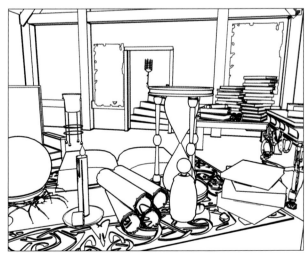

Step Three

Next, add all of the inked-in details. This is probably the most time-consuming part of the process, mainly because this image has so many elements to deal with. However, this is also part of the fun as you try to come up with the right textures and shading for each element. Try not to tackle too much at once; start with one item and work your way around the picture.

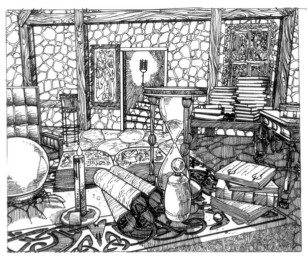

Step Four

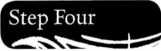

Apply an overall colour wash, using a heavier yellow for the area around the candle flame, a light reddish-brown for all of the wood beams and furniture in the background, and a light purple-grey for the stone walls and floor. Apply a yellow wash to all of the objects in the picture that are light in colour and that might receive light from the candle, such as the pages of the books, the hour glass, the parchment, the crystal ball and the table top.

Step Five

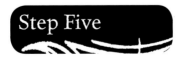

Make the final colour tighter and more refined by adding the glow around the candle using a light application of chalk, pastel or even powdered pigment. Add white highlights to the glass objects and to the deep shadows around the room to give your picture the finishing touch.

Witch's House

Witches were usually outcasts of their communities and lived alone on the outskirts of towns and villages, or in remote forests and dark haunted woodlands where few dared to roam. A witch's home was often old, dark, foreboding and bathed in magical energies. They frequently had extensive gardens for growing strange and sometimes deadly plants and herbs for their potions. Candles, oil lamps and fireplaces provided the main light inside but passers by might also see the unearthly glow of magic through the windows.

The Witch's House by Angela Barrett
A full moon casts an eerie light over the lonely house, which is almost completely obscured by the overgrown surroundings. A black cat, eyes aglow, lurks in the shadows that creep across the road. Near the gate, tiny dancing specks of light reveal the presense of faerie folk come to call. A ghost-like cloud of smoke escapes from the chimney, the only sign that someone may be at home. Is the smoke from a warming fireplace or a powerful spell that has opened a portal to the netherworld?

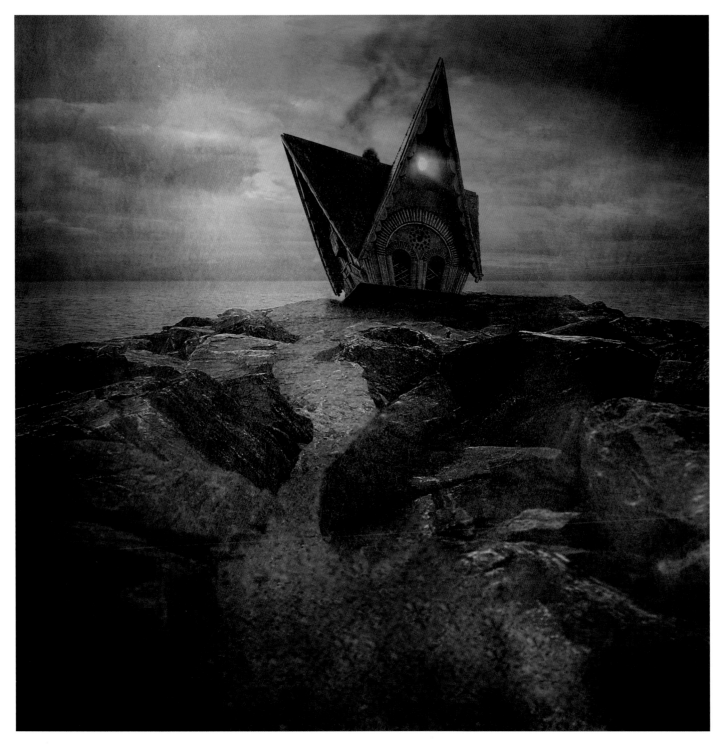

Little Witch House by Yaga
"She lived alone in her little house by the sea. She was a good kind of witch. She could watch people and punish them for their bad deeds. So be careful what you do for she is watching you all the time."

Sorceror's Castle

Sorcerers were very powerful magicians who obtained wealth, property and position in society through their advanced knowledge of the magical arts. Some became royal counsellors, oracles or even members of a ruler's trusted inner circle. Others became rulers themselves, as Sorcerer Kings commanding their own (not necessarily human) armies. Sorcerers were adept at evoking and controlling demons and other powerful and dangerous spirits. Nothing less than a large, well fortified castle or impenetrable fortress would do for these masters of the mystic arts.

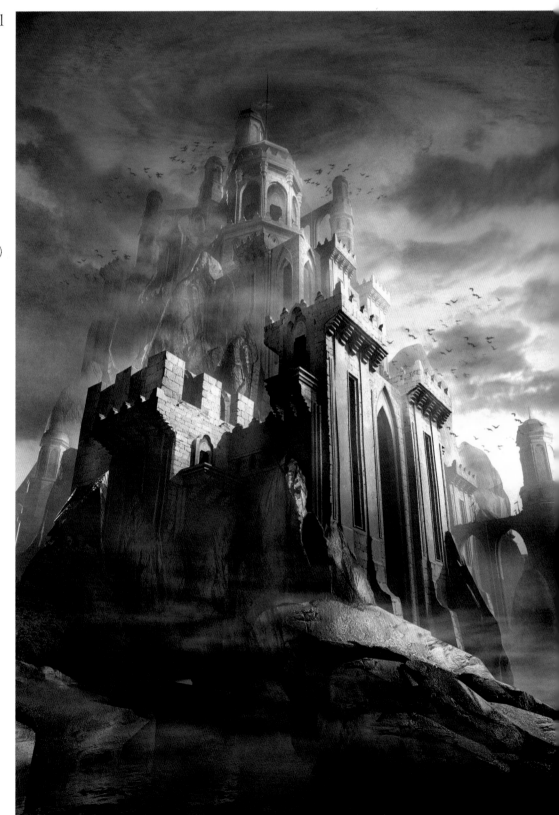

Castle by Raphael Lacoste
This huge and foreboding fortress hints at the power of he who resides within. Created using traditional media, the lower levels with high fortifications clearly display how well-defended the elegantly designed towers are. The sorcerer resides and works his magic in the upper levels, which reach into the clouds. No guards are in sight for this castle – attack at your own peril.

Drawing the Castle Bob Giadrosich

Step One

You could show the entire structure and setting of **the castle**, but a closer view can have far more impact, **particula**rly when you develop the storm brewing **in the ba**ckground. To achieve this lighting effect **requires b**old treatment and quick positive decision; **feel for th**e rhythm that sweeps off the pen to create **the omin**ous-looking clouds. Find the line of change **be**tween **l**ight and shade, then look at the colour of the lit **an**d shaded areas. Despite its dark setting, the strong contrasts and dark objects illuminate the side of the castle so that it gleams with reflection.

Step Two

A closer view of the castle allows the rest of the magical construction to be left to the imagination. Use your sense of three-dimensional vision to give the castle apparent solidarity. Try drawing lines that travel around the castle walls – as if they were strings tied around it – to give the impression that they are protruding. Different shadow tones define surface angles, so use a variety of line weights to show the richness of textural changes.

Step Three

The bridge and fort may look challenging to draw, but observe the different areas of changing texture and indicate these with crosshatching. Remember, intersecting lines give form and recession.

Step Four

The fog/cloud bank featured below the castle suggests that it is floating. To add this colour tonally, use soft, crosshatched shading.

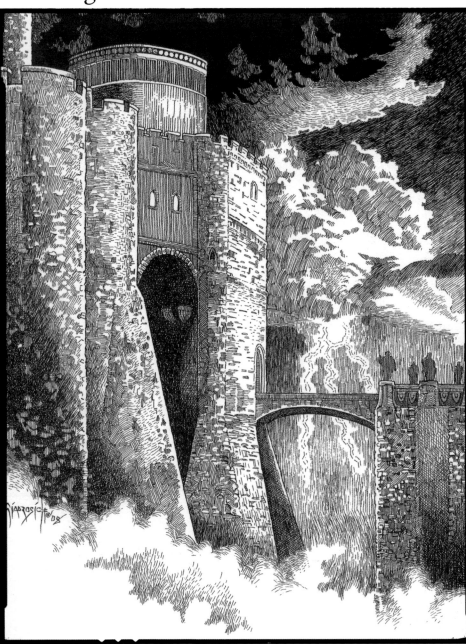

FURTHER STUDY:

Faust, Heinrich Cornelius Agripps, Aleister Crowley, John Dee, The Ascended Masters, Ceremonial Magic, King Solomon, Hogwarts

Enchanted Forest

The forest is home to faeries and other magical creatures. Sometimes the forest itself can be magical when the spirits of the gods, goddesses and other enchanted beings inhabit the plants and animals that live there.

Step One

First, find references for various forest plants. Use these as inspiration to create a loose sketch to work out the layout and flow of the image. To create a somewhat whimsical composition, include lots of curving lines, as shown left.

Refine the elements by tracing over the first sketch with a sheet of tracing paper or on a light box. Create a fine outline of the main foreground (big leaves, vines and berries) and middle ground (tree and its hanging leaves).

Step Two

Pencil in the outline image with finer details and then go over with ink. Use thick outlines around the foreground objects to bring them closer to the viewer. Use a lighter outline for the middle ground and an even lighter and finer line for the background forest glade. The dark moves forward and the light recedes. You can use a great deal of hatching and crosshatching to build up the forms (see pages 18–19).

Step Three

Use a wash of solid colour on the foreground elements. They should have a richer colour than the elements that are behind them.

Step Four

Continue to lay a wash of predominantly green over the entire picture, making the value of the green lighter towards the background. Finish up by adding shading. What you will end up with is a picture of a lush forest glade that glows with the emerald radiance of faerie magic.

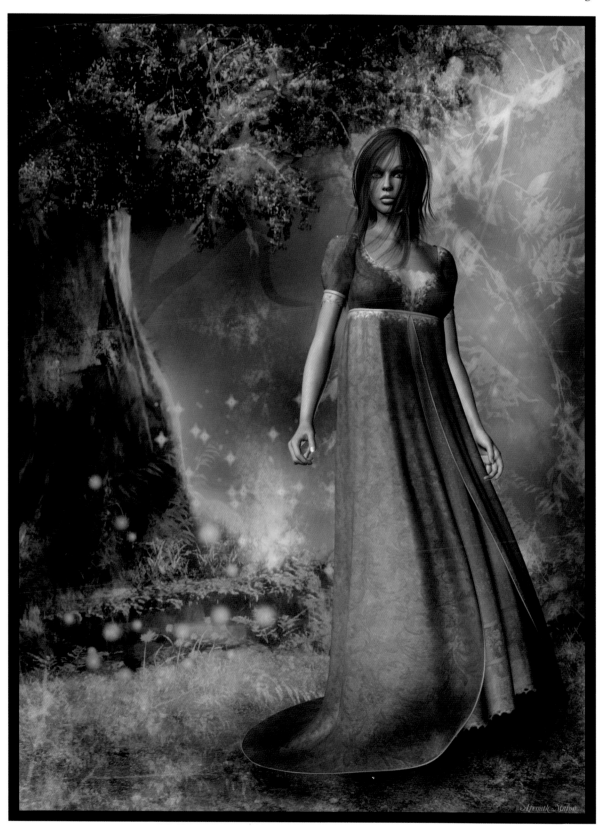

Enchanted Forest by Asenath Mason
Cautiously the green witch pauses and listens to the sounds of the forest. Nearby, the tiny sparkles of ethereal light dance, rising from the ground, heralding an arrival. These are magic woods, ruled by the faerie lords and the green witch has come to seek their counsel.

Tombs and Graveyards

The graveyard has long been a place of mystery and dread to many. However, to witches and other magical folk, the graveyard can be an important place. It is here where one can speak to those who have passed away, or 'crossed over the veil' as it is called in the world of witchcraft. Graveyards have powerful energies surrounding them and magical folk can tap into these. Graveyards are most active with the spirits of the dead during the sabbath known as Samhain, which most non-witches refer to as Halloween.

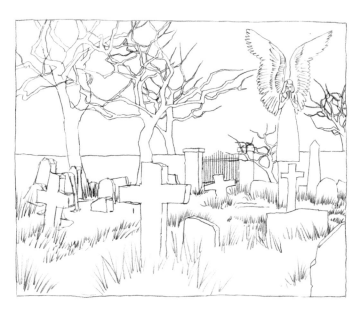

Step One

Start with a rough pencil sketch to map out where you want all of the elements to be. It may take several sketches to get things into a pleasing composition. Be patient, and make good use of tracing paper or sketching paper.

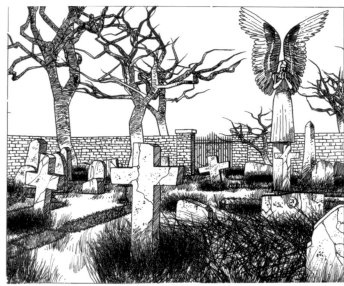

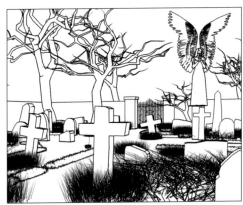

Step Three

Now fill in the outlines with details, such as bricks on the walls, cracks on the gravestones, bark on the trees, etc. Add as much or as little detail as you desire.

Step Two

Next, outline the elements of the composition in ink. You can use fine hatching and crosshatching to develop the weeds surrounding some of the gravestones.

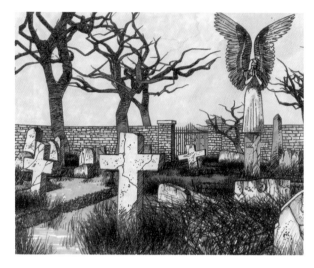

Step Four

Wash over the entire picture with a light bluish-grey, then add a pale green to the ground. Use a wash of light purple on all of the stone objects and a wash of brownish-grey on the trees. Try to keep the entire colour scheme of the picture moody and cold to reflect the content.

Step Five

Finally, add rusty browns and oranges to give the look of age and decay. The oranges also add a bit more colour to what would otherwise be a very dull image. Now what you have is an abandoned graveyard in the last days of autumn, with the cold lonely months of winter fast approaching.

Dark Tomb by Bob Hobbs
A cold blue light seeps in from a full moon high in the night sky. Small creatures scurry in the shadows, avoiding the ancient sarcophagus that dominates the centre of the tomb. In the dead silence, one can detect the faint but unmistakable sound of stone scraping on stone. Something is moving... something is not quite dead... rising to the summons of a Necromancer's call...

**Path to the Gothic Choir by
Raphael Lacoste**

"With my piece 'Path To The Gothic
Choir...', I wanted to create a picture
inspired by one of my favorite 19th
century painters, Caspard David
Friedrich. I love his works on Eldena
Abbey's Ruins. He did a series of
paintings on this subject and I love
the haunting feeling conveyed. The
original painting depicts a wintery
scene, from a more distant point
of view. I wanted to try something
different and be closer to the monks
and the ruins, feel more immersion
and dive into this haunted setting."

Urban Landscape

No longer forced to live on the outskirts of villages and towns as an outcast, the modern witch roams the concrete forests of the city. Today's Wicca, Goth witches, Druids and other Pagans and magical people walk freely on the streets, the rest of the population too busy to notice who moves amongst them.

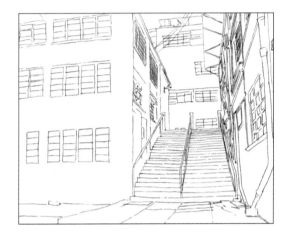

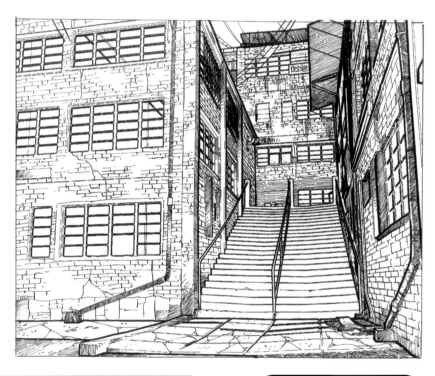

Step One

Create a pencil sketch showing an abandoned alley somewhere deep in the inner city. You can create a rendering using an architectural modelling program to use as a reference for this if you wish, but it is good to practise to know how to draw it by hand first! Remember to use your perspective correctly, and decide how many points you're going to have (see pages 32–33). You can use any image of an alley as inspiration or you could take a photo of one yourself.

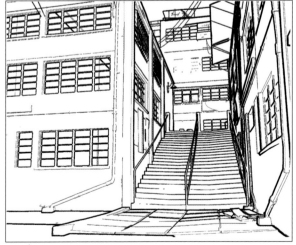

Step Three

Use ink to add in all the fine details, such as the bricks, cracks, pavement textures, metal textures and some shading. Leave a few bricks unfinished to give a sense of age and dilapidation to the buildings, as shown above.

Step Two

Using a light box or tracing paper, create a refined outline detailing all of the major elements of the composition.

Step Four

Next, add a first color wash of olive green and a burnt orange. This gives the bricks and concrete a mouldy, rusted look. Apply a deep orange and brown over the bricks and a grey to the pavement. Use a darker grey to indicate the shadows that are cast from a late afternoon sun. You can also add streaks of grey on the windows to simulate glass. To create a variation of this image, why not do a night scene with street lights casting an eerie glow and a shadowy figure lurking at the top of the steps?

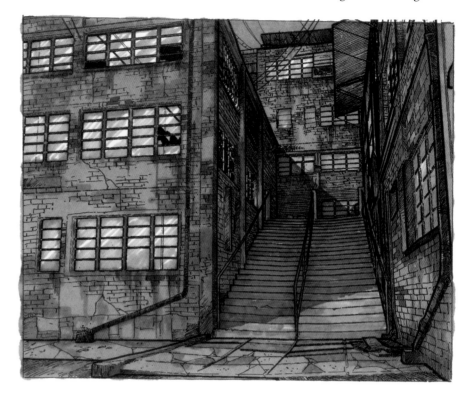

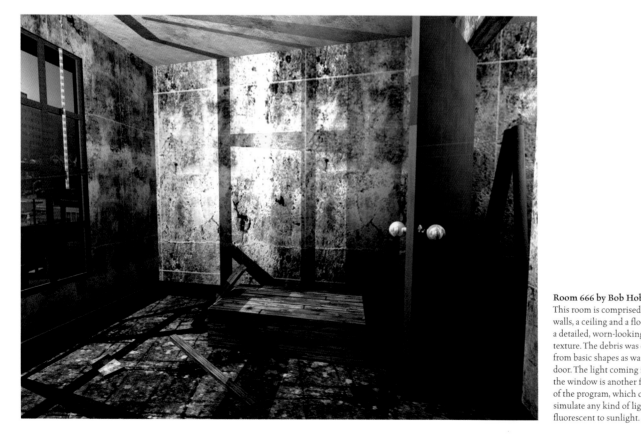

Room 666 by Bob Hobbs
This room is comprised of walls, a ceiling and a floor with a detailed, worn-looking wall texture. The debris was created from basic shapes as was the door. The light coming in from the window is another function of the program, which can simulate any kind of light from fluorescent to sunlight.

Haunted Houses

Ever since they came into existence, haunted houses have been the staple of horror movies. They can also figure quite prominently in tales of witchcraft where evil and restless spirits terrorize anyone foolish enough to venture inside. Sometimes a witch or an entire coven of witches might use an old abandoned haunted house as a place to meet and conduct rituals. This would certainly result in powerful magic energies saturating the property. These energies would attract spirits both good and evil. Some houses are haunted because a witch used to live there and has died, but her powerful spirit still roams the empty rooms.

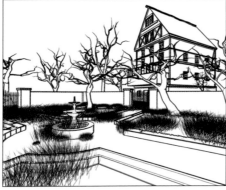
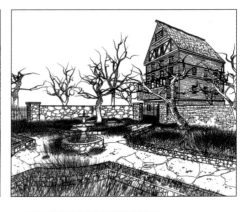

Step One

Create a rough pencil sketch to set up the composition. It is a good idea to show the surrounding area, which could include dead trees, an empty fountain and a decaying garden, to add to the atmosphere and sense of desolation.

Step Two

Use ink to refine the outline. Add in the detail on the bushes with a very fine pen point – either a fine technical pen in the 0 to 4X0 range or a crow quill pen. Use quick precise strokes to create the effect.

Step Three

Add in fine details to clearly define the image and its varied textures. You could depict some of the wall as stone and some of it as old bricks (as shown above) to highlight part of the wall as much older than the rest of the structures on the property. Feel free to use whatever materials you prefer for walls, walkways and buildings, but stick to old materials to give a sense of age and antiquity.

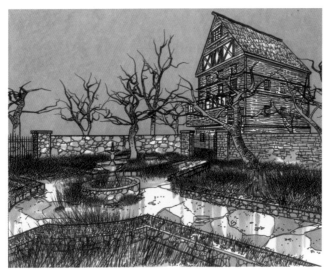

Step Four

Apply an initial wash of a greyish-violet to create the middle tone of the picture. This is a cool colour which gives the picture a very lonely, wintery feel.

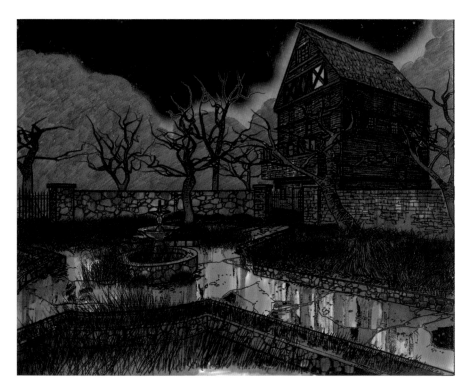

Step Five

For the final touch, apply similar colours to those used in step five of the graveyard illustration on pages 114–115. The rusty oranges and browns will give some natural colour and enhance the sense of decay. You could streak the colour wash on the pavement and on the grey clouds to suggest that it has just rained. Your picture now shows an old haunted house just after a cold, wintery rain. Why not add in a single light in an upper window to indicate the ghostly glow of some evil entity from beyond the grave?

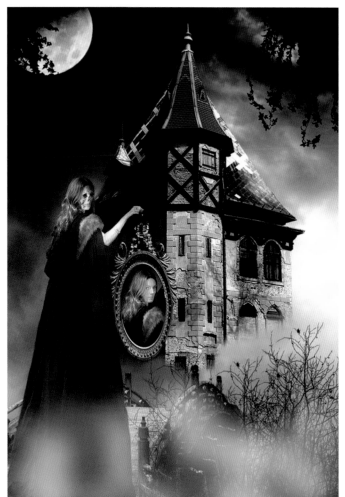

Mother of the Disappeared by Poerti
This image was created using a technique called photo manipulation. This involves using the latest 2D software, such as Photoshop, to alter and blend photos and artwork in a sort of digital photo montage. The results can be quite striking.

Chapter Five:
Dark Art Symbology

The terms symbol, sign, sigil and seal are often considered to be different words denoting the same thing. However, there are subtle differences between them. Those who practice the occult arts of sorcery, alchemy and witchcraft are familiar with those differences.

The use of magic symbols is as old a practice as magic itself and the sheer number that exist is uncountable. The thousands of magical markings that exist in the worlds of witchcraft and sorcery have traditionally been used in rituals to invoke or evoke a spirit, to add power to a spell, to imbue a special tool or charm with added potency, as a secret code to conceal information, or simply as decoration.

Use symbols in your artwork to adorn magic tools, furnishings and clothing, or work them into the design of a border. You must, however, use caution, for some magic symbols contain powers within themselves and are not to be used lightly. Research the symbols to get a better understanding of them and use only those that are directly related to the theme of the artwork. This will not only add authenticity to the work, but enhance it with energies that may translate to the viewer.

The following samples of symbols, sigils, signs and seals are just a few of the hundreds that exist.

Signs
A sign is a mark that has a conventional meaning and is used in place of words or to represent a complex notion.

Illuminati all-seeing eye
Interpreted to mean that mankind is always being monitored by a supreme deity.

Cancer
Spirit's first emotional attachment to the world; emotional bonds, belonging.

Gemini
First display of intelligence by embodied spirit; curiousity, skill, communication.

The Helm of Awe
Magical symbol used by early Vikings for protection.

Jupiter
Expansion, material growth, understanding.

Leo
Spirit entering the realm of the individual person; ego development, self-expression.

Mars
Activity, enterprise, self-assertion, energy.

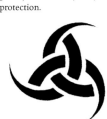

Odin's Horn
The emblem is worn as a sign of commitment to the Asatru faith.

Sagittarius
Spirit moving beyond the realm of the individual into the world at large.

Scorpio
Spirit breaking through the limitations of individual ego; change, transcendence.

Voudoun Simbi
The Voudoun God – called Loa – of Rain or Loa of the Water Snake.

Venus
Rules love and affection, the sense of touch, art, pleasure, and luxury. It is feminine.

Sigils

A sigil is a sign, word or device held to have occult power in astrology or magic. Sigils are created through a formula of words and geometric shapes by which spirits or deities may be summoned to awareness and commanded.

John Dee's AGLA
Considered God's name by magicians of the middle ages, included in magical formulas.

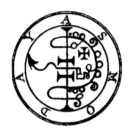

Asmodeus
Summons the art of astronomy, mathematics, invisibility and mind reading.

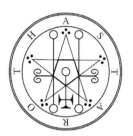

Astaroth
Said to uncover all secrets and give insight into the unknown.

Rose Cross Sigil for Happiness
To attract happiness and contentment.

Rose Cross Sigil for Love
To attract love and romance.

Rose Cross Sigil for Osiris
To invoke the god Osiris.

Lucifer
Used by modern satanists to aid in the visual invocation of the angel Lucifer.

Papa Legba
Conducts people between the visible and invisible, life and death, interpreter of gods.

You could invent your own sigils if you prefer, perhaps using your initials – or in fact any design you like!

Invented Sigil 1

Invented Sigil 2

Invented Sigil 3

Invented Sigil 4

Symbols
A symbol is something that stands for or suggests something else by reason of relationship, association, convention, or accidental resemblance.

Alchemy – symbol for sulphur
Man's attempt to manipulate metals. Each alchemist guarded their formulae and experiments by recording in symbolic text.

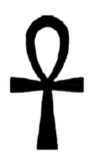

Ankh
Ancient Egyptian symbol for life. Also known as the Ansata Cross, representing male and female, the sun as rebirth, immortality and completion.

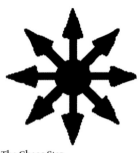

Baphomet
Worshipped by the French Knights of Templar- medieval crusader monks accused of witchcraft.

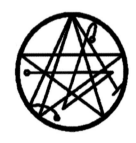

The Chaos Star
A recent addition to ritual magic, eight arrows radiating from a central point depicts the endless paths for chaos.

The Cross
Cross symbols are among the oldest on earth, and are almost invariably symbols of the sun, the sky, and the passage of time.

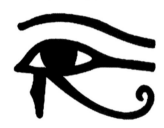

Eye of Ra
Represents the Sun God Ra. Also known as the Eye of Horus, it is said to have healing and protective power.

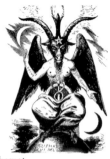

Mandala
Employed for focusing attention; as a spiritual teaching tool; for establishing a sacred space; and as an aid to meditation.

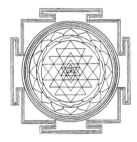

The Necronomicon Gate
Believed to be an ancient book of evil magic. Said to exist and effect on a subconscious spiritual level.

Om
The four parts symbolize four stages of consciousness: awake, sleeping, dreaming, and a trance or transcendental state.

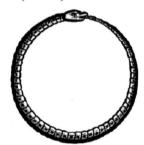

Oroborus
Depicted as the head of a snake swallowing its tail, it symbolizes the sun, cycle of life, death and renewal.

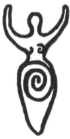

The Goddess
A simplified silhouette of a paleolithic Egyptian mother goddess, often used to symbolize the feminine deity of witchcraft.

The Triple Goddess
Represents the three aspects of the moon – waxing, waning and full. A symbol for the feminine polarity of the universe.

Triquerta
Witches using this to symbolize their faith generally believe it is of Norse and Germanic origins. Celtic witches or druids use it either to represent one of the triplicities in their cosmology and theology or to symbolize one of the triple Goddesses.

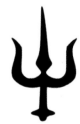

Trishula
Usually a Hindu religious symbol, the three points have various meanings in Hindu mythology. They are commonly said to represent various trinities–creation, maintenance and destruction, past, present and future or the three gunas.

Yin Yang
The Yin Yang or Tai Chi symbol represents the Sun (man) and the Moon (woman), created from the Chinese's observation of the seasonal sun shadows. The two fish eyes represent the overlapping of the seasons.

Seals

A seal is a symbol or a mark of office. All of the following examples are used in Enochian magic.

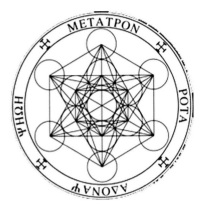

Archangel Metatron

Metatron, a fiery energetic angel who protects the spiritually gifted, is assigned to the sustenance of mankind and holds the link between human and the divine.

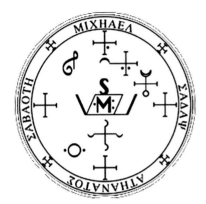

Archangel Michael

Michael, archangel of the North, is the angel of protection. Michael is often invoked for protection from invasion by enemies and from civil war.

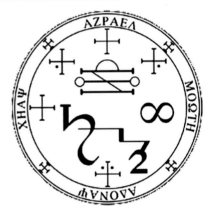

Archangel Azreal

When Azrael was elevated to the status of Archangel, he was given the duty of making sure no souls were misdirected away from Heaven.

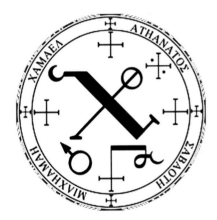

Archangel Camael

An angel who presides over beauty, joy, happiness, and contentment, Camael grants these gifts to those who pray to him.

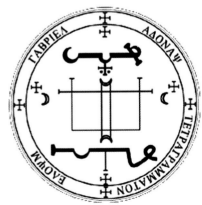

Archangel Gabriel

Gabriel, Archangel of the South, is the angel of mercy, annunciation, resurrection, vengeance, death and revelation. Gabriel is the primary messenger of God, bringing divine announcements and revelations to humankind.

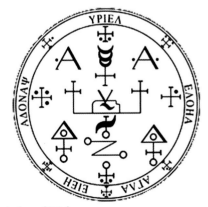

Archangel Uriel

Archangel of the East, a patron angel of literature and music, Uriel bestows the gift of creative fire, as well as the power of prophecy. Uriel is an angel of transformation, of salvation, and is the spirit of ministration and peace.

Witchcraft Writing

Occult writing systems were used to record information in secret code, for spell-casting and to imbue magical implements with added power.

Illuminati Ciphers

The Illuminati was an exiled branch of Freemasons who explored the realm of immortality, the occult, astral travel, quantum mechanics and communication with higher intelligence in secrecy away from the watchful eye of the church. The views and ideas of the Bavarian Illuminati were feared because they were often steeped in controversy against the church, the government and society. The books were sometimes written in a code called the Illuminati Ciphers.

Malachim/Alphabet of the Magi

Heavily influenced by the alphabets of the time, the Alphabet of the Magi was invented by Theophrastus Bombastus von Hohenheim (also known as Paracelsus) in the 16th century. It was used to engrave the names of angels on talismans for protection.

Theban Alphabet

Also known as the Runes of Honorius and the Witches' Alphabet, this was used to code spells and magical writings on talismans. It bears little resemblance to any other alphabet and is believed to be a Latin cipher.

Coptic Alphabet

During the Common Era an entire series of texts or writing styles were being developed. The Coptic alphabet was a combination of Greek and Demotic, which stemmed from the Egyptian hieroglyphic system.

Enochian Alphabet

Said to be a gift from the angels to the 16th-century astrologer and magician Dr John Dee. Its use is fundamental in the practice of true Enochian magic said to invoke angels.

Ogham Alphabet

Referred to as the Celtic Tree Alphabet, this is believed to be a cryptic alphabet created to provide a secret means of communication.

Egyptian Hieroglyphic Alphabet

This is one of the oldest forms of writing. It is relatively straightforward, with signs divided into three categories: logograms (signs that represent the actual); phonograms (signs that represent one or more sounds); and determinatives (signs that add meaning to the group of signs that precedes them). This is used in magic, religion, amulets, talismans, figures and spells of both the positive and the negative kind.

Passing River

Created in the 16th century by Heinrich Cornelius Agrippa, this is derived from the Hebrew alphabet.

Angelic Script

Created in the 16th century by Heinrich Cornelius Agrippa, this is used for direct communication with angels.

Dead Sea Scrolls

This is magical text written in a form of Hebrew and Aramaic.

Zayin Vau He Daleth Gimel Beth Aleph

Nun Mem Lamed Kaph Yod Teth Cheth

Tau Shin Resh Qoph Tzaddi Pe Ayin Samekh

FURTHER STUDY:
Heinrich Cornelius Agrippa, Three Books of Occult Philosophy, Dr John Dee, Enochian Magic, Codex Runicus, Astrology, Austin Osman Spare, Key of Solomon, Alchemy

Acknowlegements

I would like to thank all the incredible folks at David & Charles, specifically Freya Dangerfield, Emily Pitcher, Verity Muir, Martin Smith, Stacy Hill, Justin Combs and Rachel Macphail.

To the great artists who so generously contributed their stunning work to this book: Nigel Sade, Bob Giadrosich, Raphael Lacoste, Angela Barnett, Maelinn, Poerti, Yaga Kielb, Asenath Mason, Korvis, and my old partner in crime Finlay Cowan.

To my friends and family who tolerated my not always being available, and especially to Isabella for being so supportive during all the long hours.
Love you, babes.

Bright blessings of the Goddess and the God to LadyCrow and to all the Witches, and Warlocks, Goths, Vampyres, Druids, Shaman and other magickal folk I've met on my journey through the world of Shadows.

Thanks to my lovely models: Kristen (KiKi) Peotter, Leslie Parker, Amy Guinn and Doris Vallejo.

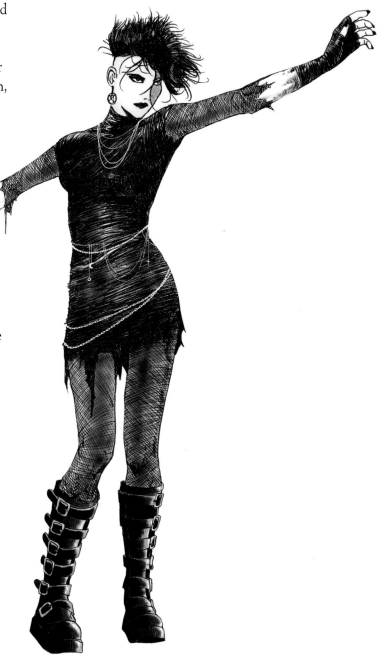

Index